IMAGES
of America

CHAUTAUQUA
LAKE REGION

Kathleen Crocker and Jane Currie

ARCADIA

Published by Arcadia Publishing,
Charleston SC, Chicago IL, Portsmouth NH, San Francisco CA

Printed in Great Britain

Library of Congress Catalog Card Number: 2002101258

For all general information, contact Arcadia Publishing:
Telephone 843-853-2070
Fax 843-853-0044
E-mail sales@arcadiapublishing.com
For customer service and orders:
Toll-free 1-888-313-2665

Visit us on the Internet at www.arcadiapublishing.com

For our mothers, Lucille F. Sullivan and Alison Cadwell, with love

Up this hill and down the next
And up and down a dozen more,
A weary lot of journeyers
We sight at last our own Lake Shore.
Chautauqua lovliest of gems
How close you guard the old home nest,
The surrounding country has its charms,
We love our very own the best.

—Mattie B. Sullivan

CONTENTS

ACKNOWLEDGMENTS

Special thanks go to each of the following for their advice, expertise, time, and indispensable assistance, which energized us throughout this endeavor: Pamela Berndt Arnold, Sydney S. Baker, A. Byron Crocker, Joan Fox, Virginia Griffin, Spike Kelderhouse, Ed Seaton, Peggy Snyder, Mary Jane Stahley, and Devon Taylor.

Our sincere appreciation goes to the following for their contributions: Cindy Anderson, Ray Anderson, Larry Arnold, Mark Baldwin, Brenda Beehler, Marilyn Bendiksen, Deanie Berg-Thorsell, Gordy Black, Joyce Brasted, Phil Cala, Linda Carlson, Edgar Conkling, Billie Dibble, Tom Dornberger, Lucy Dorr, Kay Edborg, Tom Erlandson, Dan Gates, Sharon Gollnitz, Gib Hayward, Cristie Herbst, Frances Holmes, Tom Hopson, Dorothy Izant, John Jablonski, Rosanne Johanson, Larry King, Diane Kircher, Ross Mackenzie, Chuck McDonnell, Ellis Norton, Warren Norton, Jon O'Brian, Brigetta Overcash, Patty Panebianco, Brenda Peterson, Greg Peterson, Prudence Putnam, Gil Randall, Jim Riggs, Linda Spitznagel, Vicki Strong, Barry Sullivan, Janis and Michael Walsh, and Karen Yeversky.

The courtesy lines identify the image contributors, to whom we are truly grateful.

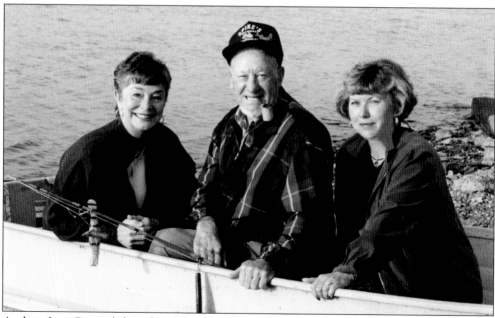

Authors Jane Currie, left, and Kathleen Crocker, right, enjoy an outing with Chautauqua Lake's premier fishing guide, Spike Kelderhouse, at his Maple Springs launch on an unusually warm December 2001 morning. (Courtesy Pamela Berndt Arnold.)

INTRODUCTION

Chautauqua Lake is the region's greatest asset. John Luensman, Chautauqua County planning director from 1960 to 1975 and the director of the county's Department of Planning and Development from 1975 until 1990, heralded the lake's importance in three areas: "a transportation route, a fishing place and a recreation source."

Early pioneers, families emigrating primarily from eastern New York, New England, and Pennsylvania, found this region to have a wealth of natural resources that provided their sustenance and livelihood. Its waterpower, abundance of northern hardwood forests, fertile soil, moderate climate, and incomparable beauty engendered development around the lake and also fostered an active social scene and booming tourist industry.

To increase business on weekends and especially in the summer season, local companies developed an extensive network of steamships and trolleys to attract Jamestown residents and excursionists from nearby cities and towns to Chautauqua Lake. Passengers were induced to escape from their daily routines to spend leisure time at hotels, parks, and camps located around the lake and to take advantage of an overwhelming number of recreational opportunities.

Because this book is designed to be an overview of the Chautauqua Lake region from the late 1800s through the mid-1900s, we chose to concentrate on the periphery of the lake. Since the city of Jamestown, with its own fascinating history, merits a separate volume to do it justice, we deliberately included only those images that relate to Jamestown's founding, its pertinence to early transportation, some representative industries, and the bustling area around the boat landing.

Because of the generosity of contributors, we agonized over image selection, attempting to share only those of the finest quality and most representative of the region in that time period. We realize, however, that every image has a story of its own and is of importance to someone. We encourage readers to value family photographs, preserve them, and pass them along to future generations so that individual histories survive.

This particular endeavor is a nostalgic collection of carefully selected histories to perpetuate memories of the heyday of the Chautauqua Lake region, and we have made every effort to ensure accuracy. For further information about the region, please check the bibliography at the back as well as our first Arcadia publication, *Chautauqua Institution, 1874–1974*.

—Kathleen Crocker and Jane Currie

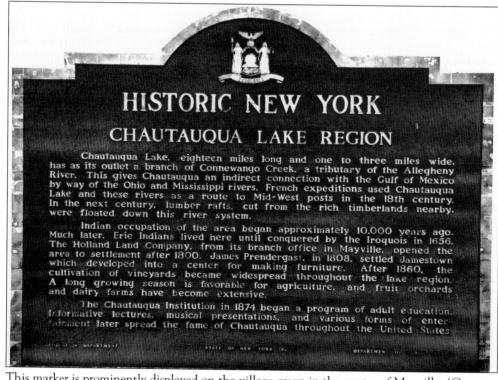

HISTORIC NEW YORK

CHAUTAUQUA LAKE REGION

Chautauqua Lake, eighteen miles long and one to three miles wide, has as its outlet a branch of Connewango Creek, a tributary of the Allegheny River. This gives Chautauqua an indirect connection with the Gulf of Mexico by way of the Ohio and Mississippi rivers. French expeditions used Chautauqua Lake and these rivers as a route to Mid-West posts in the 18th century. In the next century, lumber rafts, cut from the rich timberlands nearby, were floated down this river system.

Indian occupation of the area began approximately 10,000 years ago. Much later, Erie Indians lived here until conquered by the Iroquois in 1656. The Holland Land Company, from its branch office in Mayville, opened the area to settlement after 1800. James Prendergast, in 1808, settled Jamestown which developed into a center for making furniture. After 1860, the cultivation of vineyards became widespread throughout the lake region. A long growing season is favorable for agriculture, and fruit orchards and dairy farms have become extensive.

The Chautauqua Institution in 1874 began a program of adult education. Informative lectures, musical presentations, and various forms of entertainment later spread the fame of Chautauqua throughout the United States.

EDUCATION DEPARTMENT STATE OF NEW YORK 19 DEPARTMENT O

This marker is prominently displayed on the village green in the center of Mayville. (Courtesy Jane Currie.)

One

OVER THE
PORTAGE TRAIL

The Chautauqua Lake region played a significant role in American history. It was of special interest to France and its holdings in the New World. According to early records, French engineer Chaussegros DeLery was one of the earliest white men in the Chautauqua region, sent in 1739 to discover the shortest route between Lake Erie and the headwaters of the Ohio River. He crossed a line of low irregular hills known as the Chautauqua ridge, which forms a watershed, separating waters that flow into Lake Erie from those that flow into the Gulf of Mexico.

On one side of the ridge, water flows northward via creeks and streams into Lake Erie and then proceeds to the Niagara River to Lake Ontario to the St. Lawrence River and empties into the Atlantic Ocean. Conversely, the waters on the opposite side of the ridge flow southward into Chautauqua Lake and successively empty into these rivers: the Chadakoin, the Conewango, the Allegheny, the Ohio, and the Mississippi. This discovery proved extremely advantageous to the French in their disputed land claims with the English.

Because of its strategic geographic location as an essential navigation link between the Great Lakes and the Gulf of Mexico, Chautauqua Lake was of vital importance both to explorers and to early settlers. According to the first written county records penned by French explorers and missionaries, bands of roving Indians on hunting and fishing forays were the first people to traverse the nine-mile stretch between Lake Erie and Chautauqua Lake.

Although La Salle is credited with discovering Chautauqua Lake in the early 1600s, French explorer Pierre Joseph Celoron de Blainville landed at the mouth of Chautauqua Creek near Barcelona on Lake Erie in 1749. County historian Obed Edson (1832–1882) described Celoron's expedition as a "fleet of bark canoes, manned by half-naked Indians, Canadians in hunter's garb, and French soldiers in the uniform of their country [who] paddled over the waters of the upper lake." Celoron and his party, seeking a communication and military route to reinforce the French claim on territories west of the Allegheny Mountains, made a tremendous impact on the area's future. Their military activities against the British, documented by

Celoron's own maps and manuscripts later purchased from France by the United States government, were just the beginning of a series of incidents that eventually led to the French and Indian War. Celoron's encampments included not only the village on the west side of the lake later named in his honor but also explorations around present-day Long Point and Greenhurst.

Four years later, Marquis Duquesne, the governor-general of Canada—or New France, as it was then called—was desirous of establishing a series of forts uniting those in his country with those along the Mississippi River down to Louisiana. With the discovery of the comparatively short route between the two sites, Fort Duquesne in present-day Pittsburgh became a reality in 1754.

Trailblazing through vast virgin wilderness and a precipitous gorge in the Chautauqua region, Celoron and his party followed an abandoned Indian path and successfully built the Portage Trail between Barcelona on Lake Erie and Mayville at the head of Chautauqua Lake. Recognized as "the first work performed by civilized hands within the limits of Chautauqua County," this endeavor enabled the French to launch canoes on Chautauqua Lake and journey to Louisiana as they had hoped.

Having attained their mission, the French vacated this region, and the old Portage Road became a highway for Chautauquans, serving as a main artery to and from the county seat in Mayville. In 1823, Capt. Gilbert Ballard, owner of the Old State Coach Tavern in Jamestown, initiated his stagecoach line. It traveled along the east side of Chautauqua Lake between Jamestown and Mayville and conveyed up to 12 passengers, their luggage in the rear boot, and the first mail service between the two villages. Outmoded coaches, wagons, and carriages were replaced by trolleys and railroads that could handle increasing numbers of passengers and freight.

The Holland Land Company, absentee landlords representing six Dutch banking houses, acquired property from Robert Morris after the Seneca Indians gave up their land claims to him in the Big Tree Treaty of 1797. The company bought more than three million acres of land in western New York and opened its first sales office in Batavia in 1801. Chautauqua County purchased a little over 1,000 square miles from the Holland Land Company, which then opened another office in Mayville. Hired as the earliest agents were Paul Busti, Joseph Ellicott, and William Peacock, who managed the county's business affairs.

Inns and taverns were established to accommodate travelers along the Portage Trail. One of the most famous was immortalized by Judge Albion W. Tourgee in his 1887 historical novel of the same name, *Button's Inn*. It was "located upon that cross-artery of traffic which led back from the harbor [near Barcelona] toward the settlement around the lake beyond the divide known . . . as Jadauqua and . . . as Chautauqua." Built by Moses Chapman in 1823, the inn and its 100-acre lot was purchased the next year by the Button family. Tourgee tells his readers that the inn "was intended at first to serve both as a fort and a residence, its upper story overlapping the lower as to prevent assault," and that it later was "a favorable resting-place, not only for those who climbed the ridge upon their way to and from settlements [but also for many] wayfarers." Reputed to have been haunted, this stagecoach stop featured a barroom and a ballroom, where visitors could square dance and enjoy Virginia reels. It was razed and, later, a marker was placed near the original site, a tribute to the inn's historic importance. (Courtesy Patterson Library, Westfield, N.Y.)

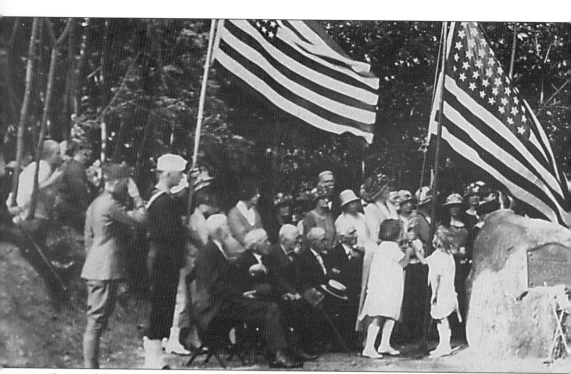

In an elaborate 1924 ceremony, the Patterson Chapter of the Daughters of the American Revolution (DAR) placed this inscribed boulder on the site where the old Indian trail and the French Portage Road intersected. Carrying their canoes, provisions, and bartering goods, the

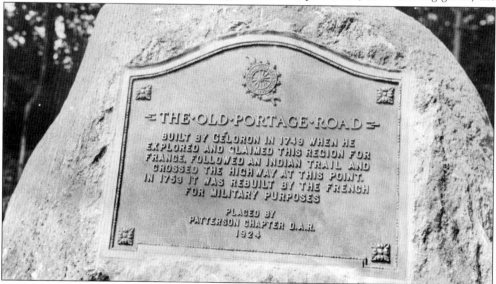

The civic-minded members of the DAR might be interested to know that avid conservationists are currently waging a campaign against the New York State Department of Transportation to preserve the 125-year-old trees along this historic highway. Today, the thoroughfare itself still serves those traveling between Mayville and Westfield and, although it is located nearby, the modern road deviates from the path of the original trail. (Courtesy Patterson Library, Westfield, N.Y.)

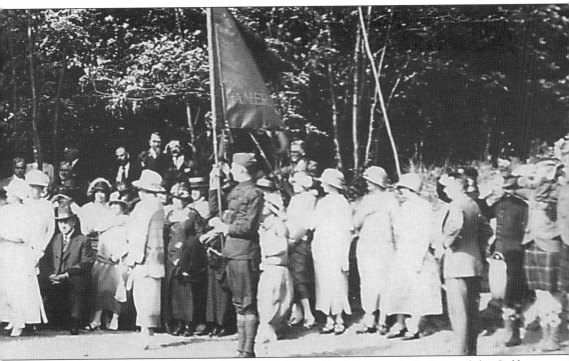

French rebuilt the primitive trail, an essential commercial link between Lake Erie and the Gulf of Mexico. (Courtesy Patterson Library, Westfield, N.Y.)

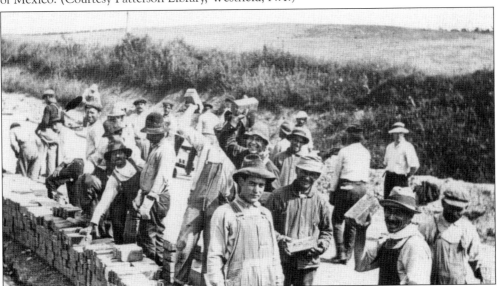

By 1852, Chautauqua County had four wooden, or plank, roads with periodic tollgates, built over the wilderness trails by the Holland Land Company. The Westfield-Hartfield Plank Road, still in existence, branched off to Mayville to provide an essential highway between Lake Erie and Chautauqua Lake. These turnpike roads lasted only a decade before they were replaced by dirt roads, with the tollgates removed. Photographer Bertrand Taylor recorded hired laborers laying brick to modernize the Portage Road in 1915, prior to the age of paved highways. (Courtesy Devon Taylor.)

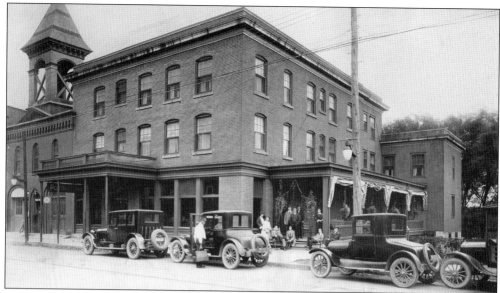

Built *c.* 1909, the three-story brick Portage Inn was another hostelry catering to travelers on the road between Barcelona and Mayville. With the Chautauqua Traction stop eventually at its front door and conveniently located near the busy Westfield railroad depot, the hotel was well known to commercial travelers between New York City and Chicago and especially popular with travelers from Buffalo and Cleveland, who made repeated visits because of its location, reasonable rates, cleanliness, and bounteous meals. (Courtesy Kathleen Crocker.)

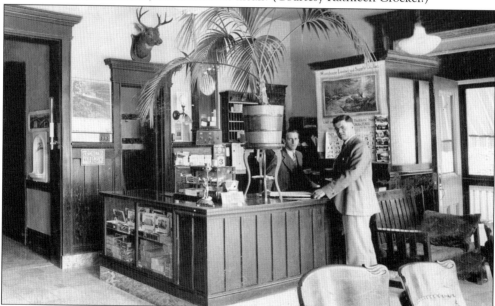

The lobby of the Portage Inn was handsomely furnished. Note the lounge chairs, marble floor, and corner reception desk, where the owner's son, James Sullivan, was often on duty during his father's proprietorship, from 1919 to 1938. During menacing Lake Erie snowstorms, other family members were called upon to assist the staff. Serving as additional chambermaids, waiters, and waitresses, they were often needed to accommodate overflowing numbers of stranded travelers. (Courtesy Kathleen Crocker.)

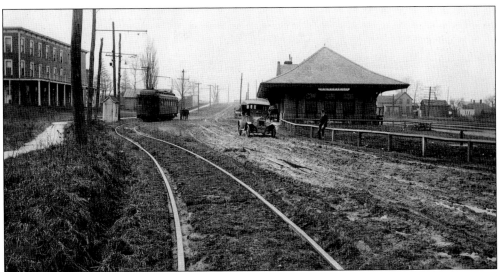

Westfield, located on the main artery, or transcontinental highway, midway between Cleveland and Buffalo, was the gateway to the Chautauqua Lake region. Because of the trolley service between Jamestown and Westfield, travelers could readily make connections with the 25 passenger trains that made daily stops on the New York Central Railroad and the Nickel Plate Railroad at the Westfield depot, seen above, and with the Pennsylvania Railroad at Mayville. By 1860, railroads had greatly increased access to the region and improved the local economy. (Courtesy Sydney S. Baker.)

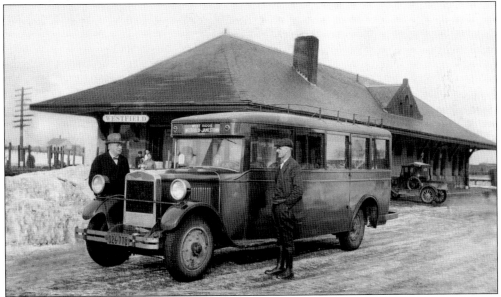

In 1926, the West Ridge Transportation Company, which had scheduled runs between Westfield and Mayville, extended its bus service to include the Chautauqua Institution and Lakewood. When the interurban trolley passenger service became defunct, these motorbuses were used to convey passengers to railroad depots as well. L.E. Burdick of Westfield complained that the 60-year-old trolley service "wasn't cut off in its heyday. It lingered until new modes of transportation shoved it as far in the background as a grey-beard with a cane." (Courtesy Patterson Library, Westfield, N.Y.)

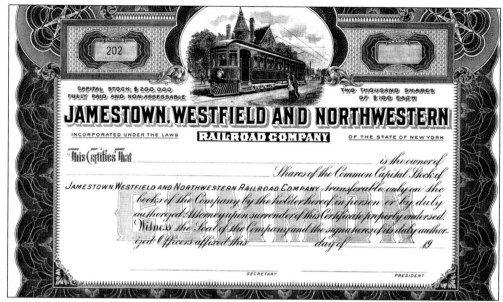

This is a sample stock certificate for the Jamestown, Westfield and Northwestern Railroad, which ran along the east side of the lake. Although it once went from Jamestown to Westfield, the last run to Westfield was made on January 21, 1950, mainly because of the excessive operating costs incurred by the steep grade through the Chautauqua gorge. Both authors' fathers took advantage of the fast service as a means to attend Westfield Academy; for their daily commute to high school, one of them would leave Bemus Point and his classmate would board at the Point Chautauqua station. (Courtesy Thomas Hopson.)

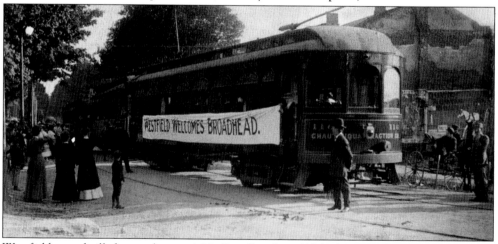

Westfield was thrilled to welcome A.N. Broadhead in 1906, the year that the Chautauqua Traction Company began its 10-mile trolley service on tracks along Portage Street. For 19 years, the line connected Westfield to Chautauqua Lake and to Jamestown, about 30 miles away. Lillian Shaw Husted of Westfield composed a verse for the celebration of the trolley line expansion; a few lines follow. (Courtesy Patterson Library, Westfield, N.Y.)

> Hail to the man, who with honest endeavor,
> Eases the burdens of horses and men . . .
> Hail to the man who has brought us the trolley
> Making the portage a short pleasant ride!

16

Two

EARLY SETTLEMENTS
AND COMMUNITIES

Obed Edson, one of the founders of the Chautauqua County Historical Society, related the trek of an "imposing emigrant train" in search of a more temperate climate and desirous of additional land in the west. Traveling in canvas-covered wagons, the families of William Sr., Jediah, Martin, Thomas, William Jr., and James Prendergast, along with William Bemus and others—altogether a party of 29—set out from Pittstown in Rensselaer County in eastern New York to wend their way westward to Tennessee.

Dissatisfied with their original destination, they crossed paths with William Peacock who, at that time, was the local land office clerk for the Holland Land Company in Batavia, near Rochester. Having surveyed the Chautauqua Lake region himself, Peacock advised the entourage to visit and then settle in what he termed the "paradise of the new world." Thus, the large Prendergast clan, one of whom would later found the city of Jamestown, and William Bemus, who had married Mary Prendergast in 1782, returned to the county after their wandering and began to make a profound impact on the Chautauqua Lake region, their adopted home. Historian Edson wrote about the Prendergasts' influence in the area: "Considering the wealth, number, and respectability of the family, it was most important that they settled upon [Chautauqua Lake's] shores."

Like others who wanted ample room for their family to grow, William Bemus (1762–1830) made an outstanding contribution to the Chautauqua Lake region. In 1805, he became the first settler in the town of Ellery; for a mere $1.50, he purchased several hundred acres of land on both sides of the lake at the narrows, built a log cabin, and established the area's first sawmill and gristmill. Soon Bemus Point, the hamlet named for him, began to grow. The first businesses included a blacksmith shop, harness shop, and tavern. Located at the narrowest part of Chautauqua Lake, midway between Jamestown and Mayville, Bemus Point was eventually developed to accommodate the growing tourist trade. A row of lakefront hotels was soon occupied by summer families in the family-oriented resort.

Around the same time, the Prendergast clan purchased a 3,337-acre contiguous tract of land on the west side of the lake located near Mayville, extending south past the Chautauqua Assembly grounds. Although not all of the clan remained there, Prendergast Point today is a private community named for the prominent family.

According to the Holland Land Company records, Dr. Alexander McIntyre of Meadville, Pennsylvania, bought one of the county's first land parcels and built his home in Mayville in 1804, about 26 years before the village was incorporated for the first time. Mayville became the county seat of government and, unlike many of its neighboring communities, assumed a residential nature rather than that of a summer resort. Located at the head of the lake, the village has stately old homes situated on hilly streets with commanding views of the lake, and seasonal cottages scattered along the shore.

The third settlement of major importance around the lake was founded by yet another member of the emigrant party, James Prendergast (1764–1846). While in search of stray horses, he first sighted the area around the Chadakoin River and was impressed with its waterpower and abundant forest. Cognizant of the potential provided by the lake's outlet as a transportation avenue and its tree-covered hills, he envisioned mills and factories being established along the river. He was convinced that the outlet location was most conducive for a lumbering and milling village, which it soon became.

In 1809, Martin Prendergast bought 1,000 acres, and two years later he deeded them to his brother James Prendergast, who purchased additional property to extend his holdings. In 1811, James Prendergast and his wife returned from Pittstown, where they were married, and settled in a log cabin on the bank of the outlet. He built a dam and sawmill nearby, and after his home and first sawmill burned, relocated in the heart of the village.

In addition to his sawmill and gristmill, other early industries included a pottery, blacksmith shop, tannery, shoemaker, and tavern. In 1813, his enterprising brothers Jediah and Martin opened a branch of their Mayville general store, becoming the first one in Jamestown, named in honor of their brother. Prior to 1815, when first surveyed by Thomas Bemus, Jamestown was called the Rapids because of the swift currents near the Chadakoin River, the outlet for Chautauqua Lake.

The Prendergast family's optimism, diligence, and generosity greatly impacted the growth of the Chautauqua Lake region, especially the early settlements of Bemus Point, Mayville, and Jamestown, where family members settled because of the sites' natural amenities.

Spurred by reliable steamboat connections and highly advertised railroad service to major cities, villages, and towns, the Chautauqua Lake region became accessible to out-of-towners c. 1867. Lakewood is a prime example of a community that evolved with the burgeoning tourist industry. Weekend, month, and seasonal vacationers, learning of the wealth of recreational opportunities around the lake, had the option of spending time at hotels, cottages, campsites, and cabins. In time, people from Jamestown and nearby Cleveland, Pittsburgh, and Buffalo built second homes in private communities such as Prendergast Point, Driftwood, and Woodlawn.

With only a minimum of industrial development adjacent to the lake and about 13 percent of undeveloped shoreline today, cottages and homes occupy the majority of the shoreline, which remains tranquil and appealing.

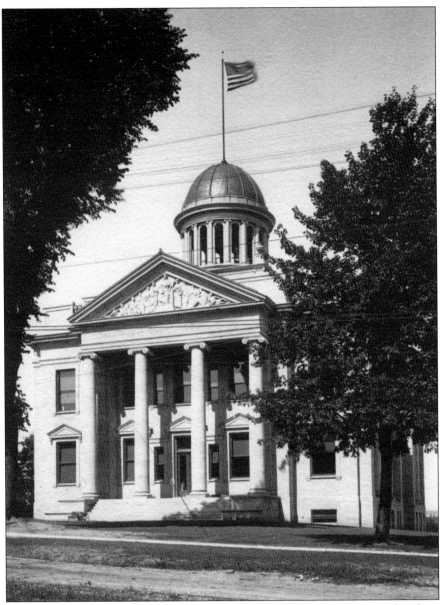

Located at the northwest extremity of Chautauqua Lake, Mayville was designated as the county seat in 1808. Before it relocated to Westfield, business conducted at the Holland Land Office Company was of principal importance to the village. Throughout the years, however, the county's legal affairs have been centered at the stately courthouse, which served as a beacon for miles around. The combination poorhouse and the insane asylum was the only county building located elsewhere. Several courthouses have occupied the site in the center of the village. The first was built in 1811 as a temporary front addition to Scott's Tavern, from which business was conducted until a more permanent facility was built a few years later. Both contained a courtroom and jury room. Finally, in 1907, the cornerstone was laid for the surviving courthouse, which is adjacent to county administrative offices and the jail. In 1854, Susan B. Anthony made the short trip from the Chautauqua Assembly to the courthouse steps, from which she spoke about women's suffrage to a small gathering. (Courtesy Sydney S. Baker.)

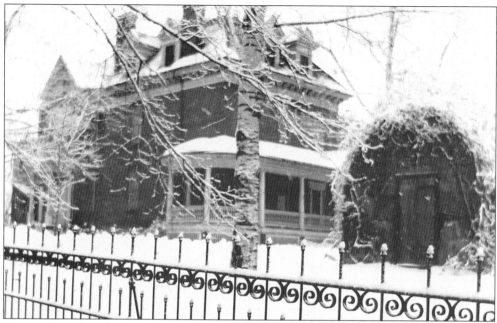

Because they thought the claims for interest and forfeiture on their hard-earned lands were unreasonable and oppressive, local farmers were outraged by the Genesee Tariff's stricter payment demands imposed by the Holland Land Company. Forced with either immediate full payment or eviction, several men formed a scheme to obtain their records. In 1836, an angry mob of several hundred armed with axes and crowbars marched from Barnhart's Inn in Hartfield to Mayville to storm the land company office in front of Judge William Peacock's home. Surrounding the office, they tipped over the building, which housed the stone vault. They stole deeds, charts, maps, contracts, mortgages, and other valuable records and hauled them on sleds back to Hartfield, where all were burned. The vine-covered stone vault, which was moved in 1967 from the courthouse lawn, remains in Mayville as a monument to the tenacity of those early settlers. (Courtesy the family of Linda and Ira Davis.)

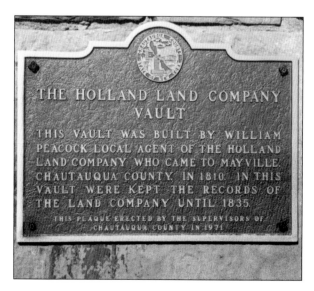

This plaque is affixed to the historic stone vault situated on the front lawn of the county courthouse. When William Peacock, local agent of the Holland Land Company, built his home in 1812, part of his residence was designed as his business office. To protect the company's valuable records, he deliberately built the stone vault as a separate entity. When the new county office building was constructed, the vault had to be moved from the Peacock Inn property to the courthouse site; great care was taken to reassemble the numbered stones to exactly duplicate the original. (Courtesy Jane Currie.)

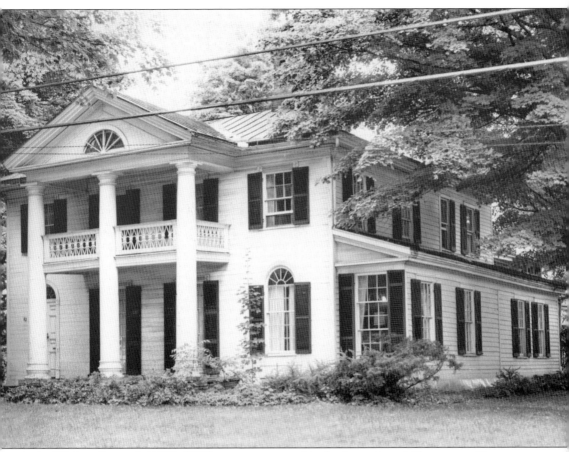

Judge William Peacock (1780–1877) was instrumental in the formation of Chautauqua County. He began as an assistant surveyor for the Holland Land Company under the tutelage of Joseph Ellicott, whose niece he married. Peacock readily recognized the value of the land in the western New York area, and he purchased much of the property he surveyed both in Buffalo and in Chautauqua County. These vast holdings brought him not only great wealth but also political clout; he became a county judge and the county treasurer. After the attack on the Holland Land Company office, which the Mayville *Sentinel* deemed "lawless and unjustifiable acts," Peacock was replaced, although he had had enough warning prior to the assault to have saved several records. In 1835, the rising attorney William Henry Seward (1801–1872) was hired to pacify and improve relations with the local settlers, and the agency was moved from Mayville to Westfield. Seward's office was located in the center of town, and his beautiful mansion, pictured above, was moved in 1966 from North Portage Street up to the Chautauqua gorge. It is now is a bed-and-breakfast establishment. Popular, trustworthy, and tactful, Seward became active in politics, serving as the governor of New York and as secretary of state in the cabinets of Pres. Abraham Lincoln and Pres. Andrew Johnson. He is best remembered for his negotiation in the 1867 acquisition of Alaska from Russia, known as "Seward's Folly." (Courtesy Sydney S. Baker.)

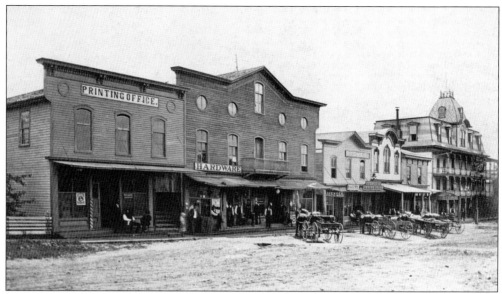

Erie Street, the commercial district of Mayville, was the extension of the old Portage Trail that led over the gorge down to Chautauqua Lake. Lining the street were a printing office, hardware store, grocery, tavern, church, bakery, harness shop, and general store—the first of which was operated by pioneer settlers Jediah and Martin Prendergast. At the far right is the Mayville House, which withstood a devastating fire in 1878 that ravaged most of the west side of the business section. In 1901, the opposite side endured the same fate. (Courtesy Sydney S. Baker.)

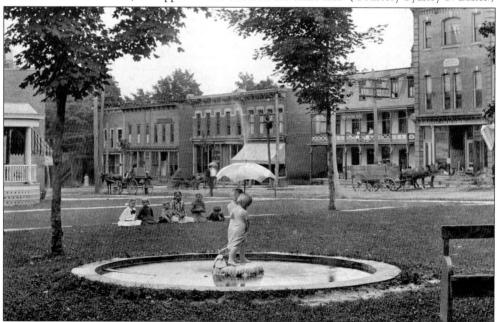

Manufactured by Joseph W. Fister of New York City, this century-old cast-iron statue adorns the village green in Mayville. The Hummel-like young boy and girl seen in this stereopticon image are sheltered by a red copper umbrella. Although it is a rather familiar piece, seen on vintage postcards and in Victorian gardens, only a handful of originals remain in the United States. (Courtesy Sydney S. Baker.)

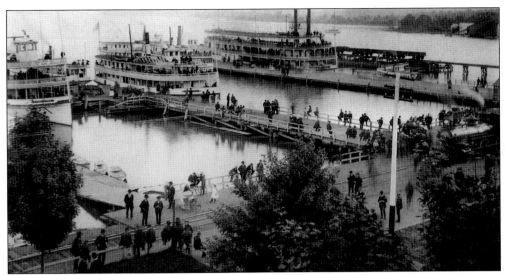

Prior to the advent of railroads, citizens journeyed to the county seat in Mayville on steamboats. Mayville's busy port was recognizable by its long docks, one of which extended from the Pennsylvania Railroad depot out over the lake. Certain steamers were assigned there on a nightly basis prepared to handle passengers who arrived overnight via rail from Pittsburgh. The spacious docks also had reserved spaces for small rental steamers and for the triangular ferry service boats, which ran to and from Mayville, the Chautauqua Institution, and Point Chautauqua. Seen in this photograph, from left to right, are the *John F. Moulton,* the *City of Cincinnati,* and the *City of Jamestown,* the largest steamer on the lake. (Courtesy Sydney S. Baker.)

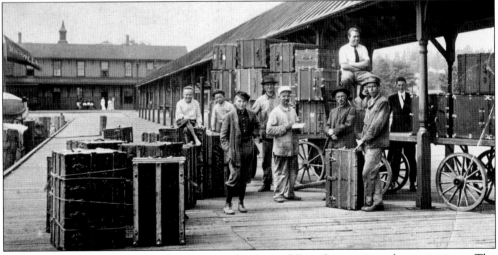

The old Pennsylvania Railroad station at the foot of Erie Street was a busy terminus. The original wooden structure housed the passenger depot, the baggage and freight terminal, a telegraph center, and administrative offices. Hired by the Broadhead enterprises, competent station agents and baggage masters were expected to provide courteous and prompt customer service, especially since the Mayville dock handled the greatest number of arrivals and departures. When it burned on May 24, 1923, the station was replaced by a small brick building, which now houses the archives of the Chautauqua Township Historical Society. (Courtesy Peter Flagg.)

Jamestown industrialist William Broadhead and sons Almet N. and Shelden B. Broadhead showed great regard for the welfare of Jamestown workers and their families, who began to indulge in leisure activities. Because of their vision and wisdom, the Broadhead investments resulted in an extensive system of steamboat and trolley transportation, which also benefited the economy and growth of the Chautauqua Lake region. They bought the Jamestown, Chautauqua, and Lake Erie Railroad and converted it from steam to an electric trolley line. The Jamestown, Westfield and Northwestern trolley operated on the east side of the lake from 1914 to the 1950s. This 1944 photograph was taken along the picturesque wooded Bemus Bay area. (Courtesy the Izant-Walworth family collection.)

In this 1899 photograph, a northbound passenger car of the Jamestown and Chautauqua Lake Railroad waited at the Bemus Point Station, located on the east side of Center Street near the present-day nine-hole golf course. Other depots on the east side of the lake, starting at the southern terminus at the Jamestown boat landing, serviced residents in the Clifton area, Griffith's Point, Long Point, Point Chautauqua, Hartfield, and Mayville. The trolley operators were met with banners and other signs of hearty welcome and enthusiasm when the line began its service. (Courtesy Chuck Hawley.)

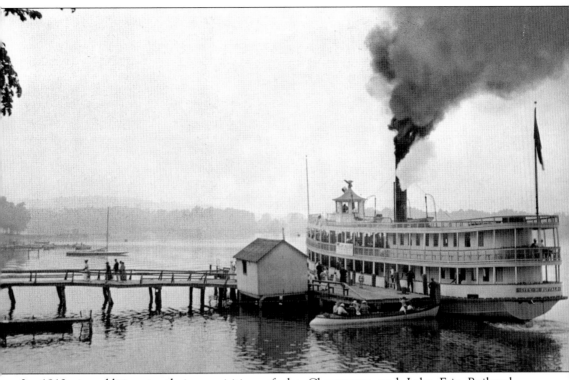

In 1913, in addition to their acquisition of the Chautauqua and Lake Erie Railroad, entrepreneurs Almet N. and Shelden B. Broadhead bought the Chautauqua Steamboat Company, which ensured their control of all transportation service on and around the lake. Following the horse-and-buggy era, the steamboat heyday on Chautauqua Lake lasted nearly 100 years. Before the availability of trolleys, lakeside residents were dependent upon steamer service for food and supplies. Local citizens and organizations enjoyed pleasurable outings, such as picnics and afternoon and moonlight cruises. In addition, crowds of vacationers were transported on scheduled trips every day from one site on the lake to another. This Bemus Point steamboat pier and public docking facility was located at the end of Main Street and is indicative of others around the lake. The major steamers—the *City of Buffalo*, in this image, the *City of Chicago*, the *City of New York*, and the *City of Jamestown*—delivered passengers and freight from railroad depots and various lakeside docks to summer hotels and residences. (Courtesy Mary Jane Stahley.)

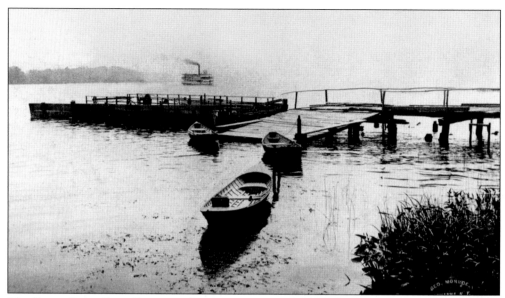

The Bemus Point-Stow Ferry was the main artery across the lake from 1811 until 1982, when the Veteran's Memorial Bridge was built. Farmers made early commercial trips across the 933-foot crossing to haul cattle to market and grain to gristmills. In later years commuters in passenger cars, only nine per trip, paid less than 40 cents to minimize driving time around the 20-mile highway linking Mayville and Jamestown. Vehicles and pedestrians queued up on each side waiting for the pilot to guide the cable-operated vessel between the shores. The ferry is maintained today by the Chautauqua Lake Historic Vessels Company, which caters to tourists who wish to experience that early mode of travel. (Courtesy Jane Currie.)

This 1917 photograph is rather deceptive. Although Fred Lawson appears to be sighting something distant, the device being misused is, in reality, an 18-inch metal horn. Posted on the Bemus Point Ferry landing, the horn was used to summon the ferry, which was docked on the Stow side of the lake. Occasionally, false-alarm blasts were made by mischievous children and adults to deliberately inconvenience the operator. Usually, however, the horn alerted the operator that someone needed to cross the lake. (Courtesy Mary Jane Stahley.)

Operation of the Bemus Point-Stow Ferry became a family business. Alton Ball assumed the management of the ferry after his father, William Ball, relinquished it. Alton Ball, along with his son Gerald Ball, met thousands of passengers during his 40-plus-year stint as operator. The large gear wheel in his left hand was powered by a steam engine that propelled the ferry along steel cables. Ball was responsible for modernizing the "hardy little conveyance" by replacing its crude hand-cranked pulley system. At his death, in 1943, the ferry was sold to the Chautauqua County Highway Department. (Courtesy Mary Jane Stahley.)

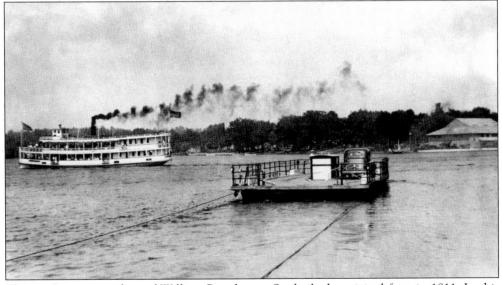

Thomas Bemus, grandson of William Prendergast Sr., built the original ferry in 1811. In this scene the ferry has left Stow en route to Bemus Point as the *City of Jamestown* journeys through the same passage. In 1806, Bemus built his log cabin at what later became known as Tom's Point, near the village of Stow. The 18-acre Stow Farm, once used as a pasture for dairy cattle and crops, remains one of the few undeveloped areas of shoreline. Intending to preserve the 1,150 feet of prime lakeshore property, one of the largest remaining tracts of natural habitats on the lake, the Chautauqua Watershed Conservancy is attempting to purchase the farm as well as procure other conservation easements around the lake. (Courtesy Sydney S. Baker.)

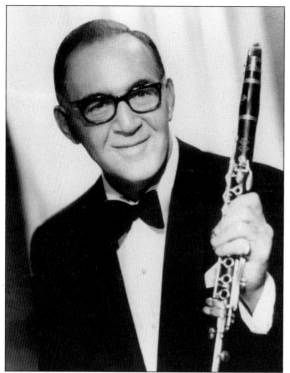

During the 1930s, steamboat passengers arrived at the Bemus Point pier to be entertained by some of the best musicians in the country. The Casino hosted one-night gigs, played in small towns, while the big bands were en route to more important engagements in New York City and Chicago. Listening from the village park or dancing in the upstairs ballroom, people enjoyed the greatest talents of that era: Benny Goodman, pictured at the left, Lionel Hampton, the Dorsey brothers, Harry James, Gene Krupa, Eddy Duchin, Rudy Vallee, Buddy Rogers, Guy Lombardo, Woody Herman, Kay Kaiser, Artie Shaw, Billie Holliday, Count Basie, Duke Ellington, Cab Calloway, Ted Lewis, and Paul Whiteman. During World War II, band travel all but ceased due to military enlistments and gas rationing. (Courtesy the Chautauqua Institution Archives.)

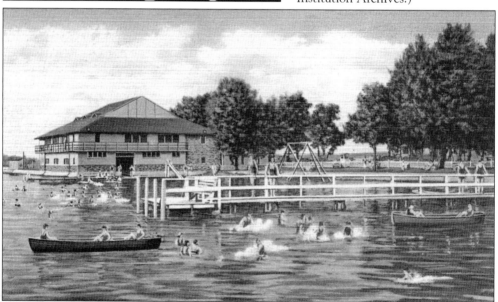

The Casino is a Chautauqua Lake landmark, built in 1930 by Pittsburgh industrialist James Selden as a recreational center for the village of Bemus Point, which continues to own it. Among its main attractions were the shuffleboard courts, game room, soda fountain, bathhouse, and bowling alley. Its adjacent playground, baseball diamond, and tennis court have drawn thousands of visitors to the site, beside the ferry landing. Until the last few years, the Casino's Great White Fleet Museum displayed steamboat artifacts, a huge draw for former owner Russ Fuscus. (Courtesy Mary Jane Stahley.)

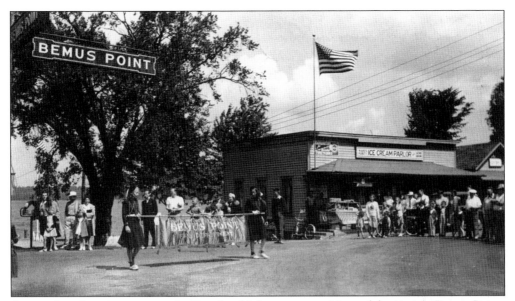

As in other American towns, the Fourth of July was an exciting celebration in Bemus Point. Banner holders, from left to right, Mary Jane Carlson (Stahley) and Onalee Hazzard (Gustafson) lead the parade in 1940. The crowd had assembled at the corner of Main Street and Lakeside Drive in front of the Ice Cream Parlor and newsstand once owned by the Ward family, now the site of the Italian Fisherman Restaurant. Since 1936, a spectacular Independence Day tradition has been the much anticipated lighting of flares around the periphery of the entire lake at 10:00 p.m. (Courtesy Mary Jane Stahley.)

This vintage photograph is of the same intersection above; the lake is off to the right and the village business center to the left. The Pickard House, on the corner, was the first in a series of inns that led down to the Casino and the ferry landing. A 1913 article claimed that "No where did the sun shine more brightly, no where is the shade more alluring, the air more bracing, the sunsets more gorgeous, or the stars so bright as at 'Old Bemus on Chautauqua Lake.'" (Courtesy Kathleen Crocker.)

29

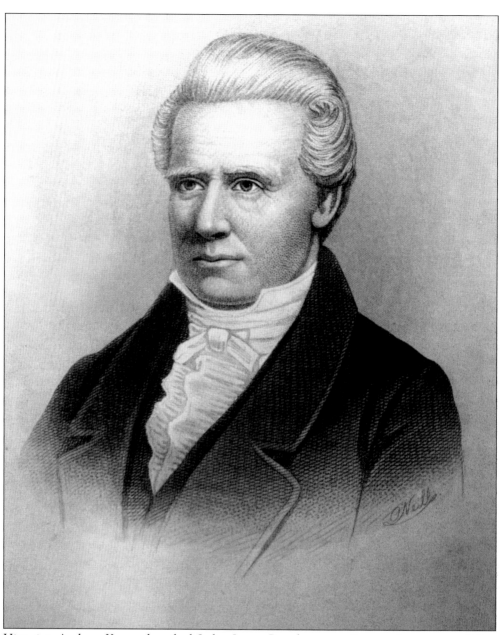

Historian Andrew Young described Judge James Prendergast as "a very large man, of fine appearance, courtly and dignified in his manner," as this drawing might suggest. Prendergast (1764–1846), a pioneer visionary who founded the city of Jamestown, made enormous contributions to the area. Although he had studied medicine in Pittstown before moving west, his career became one of a public servant. In 1813, he was elected the first supervisor of the town of Ellicott, and the following year he was appointed to the Court of Common Pleas, receiving the title of judge. Moreover, he was the city's first postmaster, serving in that role from 1817 to 1824. Beyond Prendergast's love for his wife, "Aunt Nancy," and his son Alexander Prendergast, he had great regard for his fellow citizens. In addition to financially aiding those less fortunate, he generously donated land for schools and churches.

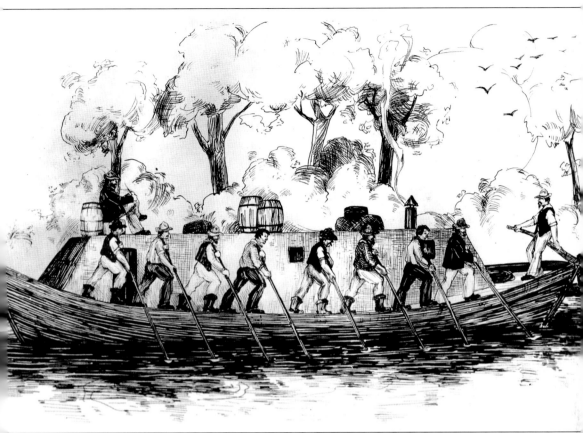

Following Indian canoes and dugouts, the primary mode of navigation on Chautauqua Lake, as shown in this naïve sketch, was the crude keelboat manned by motley crews. In addition to the keelboats (Durham boats), long canoes and flat-bottomed scows were used to transport goods and supplies from the Chautauqua Lake region downstream to Pittsburgh and other towns along the Ohio River. Cargo rafted down the rivers and sold in the larger cities included quantities of maple syrup, lumber, black salts, potash, salted fish, and furs for trade with the Indians. On their return north from Pittsburgh, the keelboats hauled materials back to the region to supply local gristmills, sawmills, woolen mills, tanneries, ax makers, coopers, blacksmiths, and carriage and wagon shops. In 1932, county historian Arthur Wellington Anderson noted that, according to town of Ellicott records, by 1830, over 40 million feet of lumber was annually shipped down the Conewango, Allegheny, and Mississippi Rivers in rafts and sold at different towns on the latter two rivers. Before Alvin Plumb built the first steamer, *Chautauqua*, in 1828 and the incorporation of the Chautauqua Steamboat Company in 1829, a futile attempt was made to utilize the "horse boat," a large scow with passenger cabins and horse stables. The experiment proved to be a failure; horses hitched to paddlewheels simply lacked the endurance to make the 17-mile journey down the lake. (Courtesy the *Post-Journal*, Jamestown, N.Y.)

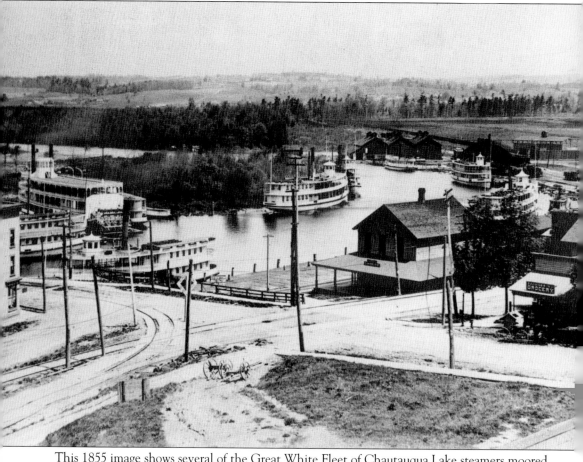

This 1855 image shows several of the Great White Fleet of Chautauqua Lake steamers moored at the Jamestown boat landing on the banks of the outlet of the Chadakoin River. Passengers could either walk or ride streetcars or trolleys to this southern terminus, about eight blocks from the city's business center. These massive steamers had ample room to turn around, even with the storage slips and docks along both sides of the river. The Hotel Riverside, lower left, was conveniently located near both the railroad depot and the boat landing. The typical steamboat route, upon leaving this location, was to keep to the east side of the lake en route from Jamestown to Mayville, beginning at the winding outlet seen in the background. Not every steamer stopped at every dock, but the basic route follows: from the boat landing to Clifton; out of the swamp to Greenhurst, Fluvanna, Griffith's Point, and Sheldon Hall; on to Driftwood, Belleview, and Bemus Point; continue to Long Point, Maple Springs, and Midway; stop at Point Chautauqua; and proceed to Chedwel, Dewittville, Hartfield, and Mayville, the final destination. In later years steamers also crossed the lake to service the depots at Lakewood and the Chautauqua Institution. (Courtesy Sydney S. Baker.)

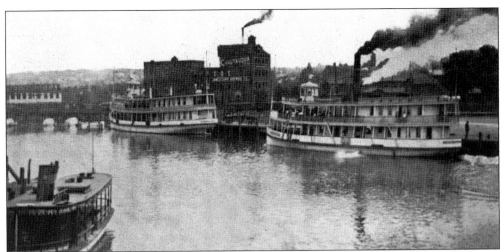

This is another view of the boat landing in front of the Jamestown Brewing Company. The Chautauqua Lake Steamboat Company adhered to a regular schedule. Steamers made 16 round-trips daily to connect with trains at Mayville, Lakewood, and Jamestown, the only depot transfer stations around the lake to carry passengers, personal luggage, freight, and mail to a variety of lakeside destinations. Timetables listing times, fares, destinations, stops, and attractions were published for each of the steamers. Throughout the summer, steamers ran the length of the lake every hour both ways from 6:00 a.m. until around midnight. (Courtesy the Merle W. Scriven family.)

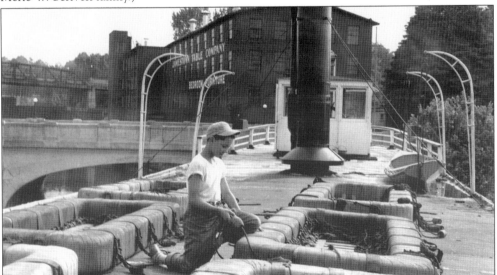

This photograph shows a young man near one of the cargo bins on the upper aft deck of the *City of Jamestown* at the boat landing. The Jamestown Table Company, later known as the Taylor Furniture Company, is in the background. Although their transportation systems were profitless ventures, Almet N. and Shelden B. Broadhead vowed to maintain them throughout their lifetimes. Therefore, with the death of both brothers in 1925, the trolley and steamboat service was "pared down to what could be profitably operated," and the heyday of the steamers was numbered. Although several continued to ply the waters, they eventually all fell into total disrepair and, when deemed unsafe, most were dismantled, scrapped, dry-docked and, finally, burned before entering their watery graves around the outlet. (Courtesy Jane Currie.)

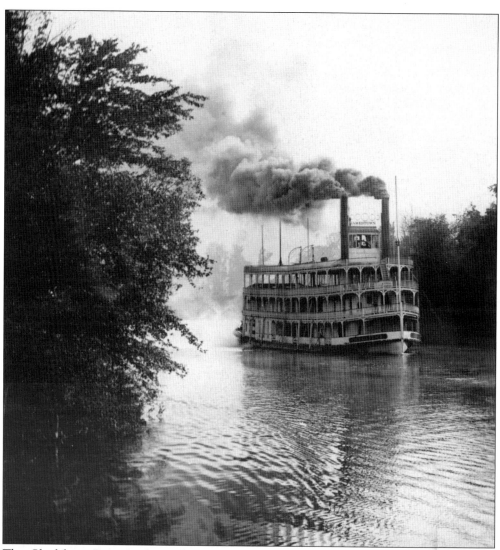

The Chadakoin River is the outlet of Chautauqua Lake. Squeezing past another steamer there was tricky business and often cause for excitement and concern. Passengers, however, were intrigued by the beauty of the ducks, geese, cranes, swans, and herons, as well as by the overhanging snake-filled tree branches that made this stretch of the journey almost enchanting. Its excessive length made the *City of Jamestown* especially hard to steer around the succession of bends throughout the three-mile narrow passage, from the boat landing to Fluvanna. But once the last bend was rounded, the vista opened wide and navigation became far easier. According to a Fenton Historical Society publication, the *City of Jamestown* "was 'saved by the bell' on three occasions to give joy to another generation." Launched as the *Nettie Fox* in 1875, the boat was the first sternwheeler on the lake. Known also as the *W.C. Rinearson* and the *City of Cleveland*, there was public outcry when it was initially slated for the scrap heap. Financial support and elbow grease were provided by the public sector, including members of the Jamestown Jaycees who invested in the boat's restoration as a civic project. In the 1950s, the *City of Jamestown*, the last of the fleet, was used primarily for charter service. Fortunately, the steamers were well photographed and documented, so their legacy remains, especially for those who think their heyday was merely make-believe. (Courtesy Sydney S. Baker.)

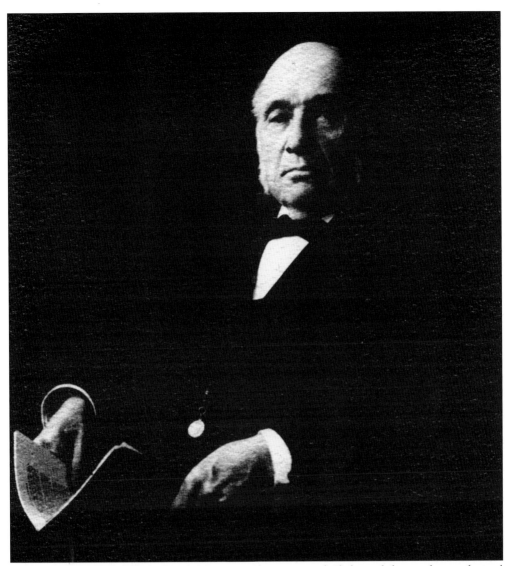

At his death, William Broadhead (1819–1910) was named "father of the modern industrial development of Jamestown" by a joint resolution of the city's Common Council and by Mayor Samuel A. Carlson. Broadhead emigrated to the Chautauqua region in 1843 from Thornton, England, where he served as both a weaver's and blacksmith's apprentice. Twenty-nine years later, after a return to his birthplace, he became interested in textiles and replicated the thriving industry of England in his adopted city. Broadhead, with a firm belief in Jamestown and its citizenry and working in tandem with his sons Almet N. and Shelden B. Broadhead, "used his limitless energy and foresight to establish Jamestown as a full-fledged industrial community" during the second half of the 19th century, a community "once known throughout the nation for its craftsmanship and progressive outlook" as Ross L. Weeks Jr. reported in a special series of the *Post-Journal*. On a more personal level, the following toast was made on Broadhead's 81st birthday in 1900: Broadhead "found [Jamestown] a village of wood and made it a city of brick and stone . . . [and] . . . furnished to our citizens means of transportation and opportunities for recreation and enjoyment that have contributed to our comfort and happiness." (Courtesy Sydney S. Baker.)

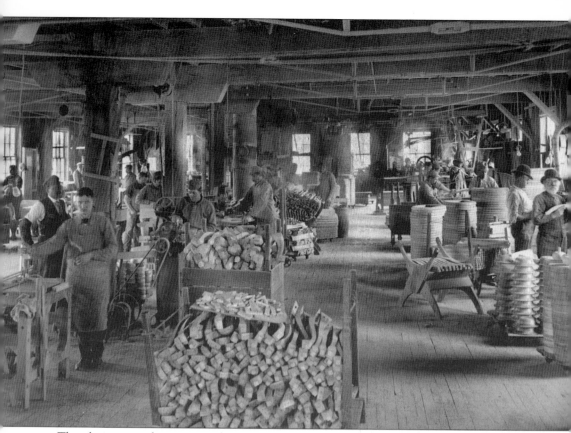

The three main factors contributing to the incomparable growth of Jamestown's furniture industry were waterpower, an abundant supply and variety of fine hardwoods, and industrious craftsmen, the majority of whom were Swedish immigrants. About 75 percent of the furniture factories in the city were once owned by ambitious and hardworking Scandinavians. In 1917, Ralph W. Taylor, previously employed by competitive companies, bought stock in the Jamestown Table Company, seen above. He assumed ownership, renamed it the Taylor Table Company, and eventually sold the business to the Ethan Allen company. A similar success story developed in Mayville. Starting with a simple tannery, Swedish native John Kling purchased a bankrupt plant to establish the family-owned-and-managed Kling Furniture Company, one of the largest producers of dining-room and bedroom furniture in the country, which the family sold to Ethan Allen. Perhaps the wisest industry marketing strategy was the cooperative enterprise established in 1917 at the nine-story Furniture Expo Building in downtown Jamestown. The semiannual displays of current products and designs attracted thousands of retail dealers from all over the country and was profitable for local manufacturers. (Courtesy Jane Currie.)

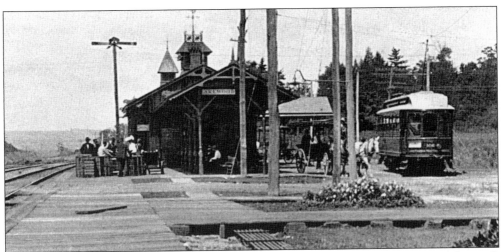

Nearly a dozen passenger trains made regular stops at the Erie Railroad station in Lakewood, shown in a c. 1906 photograph. Chautauqua Traction Company trolleys waited to transfer the railroad passengers to other resort villages and hotels on the west side of the lake, namely to the Chautauqua Institution. Both travelers and those who arrived to greet them were sheltered from inclement weather by the protective sheds while waiting for baggage masters and horse-and-buggy drivers to facilitate their arrival at the nearby posh Kent House, Sterlingworth Inn, and private docks in the vicinity. (Courtesy Sydney S. Baker.)

James Ward Packard, designer of the prestigious Packard motor car, chose Lakewood for his summer residence; his brother William Doud Packard of Packard Electric Company built an English Tudor-style mansion on the same lake, on property that later became part of the Chautauqua Institution. James Packard's widow, Elizabeth, lived long after her husband died. Even today, neighbors have fond recollections of her exquisite Lakewood Estate rose garden and, especially, of her benevolence to the community and to particular individuals. Her philanthropies included the Women's Christian Association (WCA) Hospital in Jamestown and the Village of Lakewood Fire Department, as well as her chauffeur and nearly 18 gardeners, who fell upon hard times. She helped them find jobs as painters, repairmen, and builders to ensure continued support for their families. (Courtesy Nancy Bargar.)

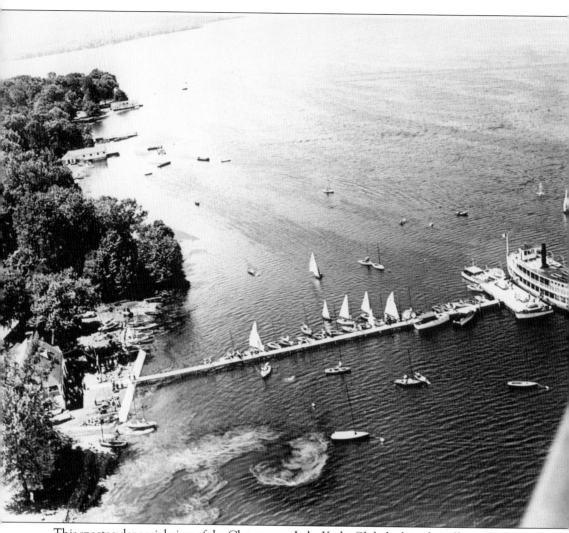

This spectacular aerial view of the Chautauqua Lake Yacht Club dock in the village of Lakewood was taken in the 1940s. Although Uriah Bentley settled on his farmland purchased from the Holland Land Company around 1810, the village of Lakewood was not incorporated until 1893. The Packards bought Lake View, a 25-acre tract, and streets and lots were carefully laid out along Chautauqua Avenue. Located about five miles from Jamestown on the southwest shore of the lake, Lakewood's growth as a first-class summer resort was due to its convenient location on the main line of the Erie Railroad. This rail, in turn, connected the village with the Atlantic and Great Western Railroad and was a regular stop for overnight passengers arriving from New York City and Chicago and for visitors from Cleveland and Pittsburgh. Christened both the "Newport" and the "Saratoga" of Chautauqua Lake, Lakewood's small winter population of 400 grew seasonally to over 2,500. Today well-kept residences are reminiscent of the Victorian era. The Lakewood Development Corporation is currently engaged in a beautification project of Chautauqua Avenue, the village's main artery, which ends lakeside at the site of the former depot. (Courtesy Sydney S. Baker.)

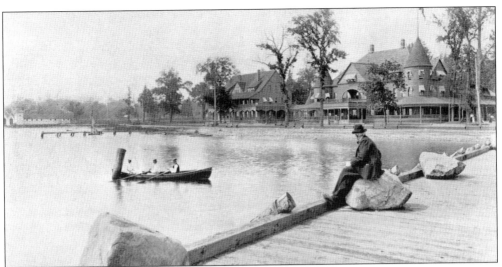

This is a view of Griffith's Point from its steamboat landing between Fluvanna and Sheldon Hall. In 1806, Jeremiah Griffith settled there on the present-day Cheney farm in Ellery. In neighboring Fluvanna, Asel Smiley operated a horse-and-buggy shop near today's Apple Inn. Another noted settler in that area was Samuel Whittermore (1799–1875), whose early career was that of a potter. In partnership with Jack Fenton until 1845, Whittermore peddled crocks, milk pans, pie plates, pitchers, cups and saucers, and tea sets throughout the county. The enterprising Whittermore then recognized the lake's potential as a summer resort area and built the first resort hotel on the lake. His modest-sized "Temperance House" was in existence until 1888, when it became a private residence. (Courtesy Sherry Johnson.)

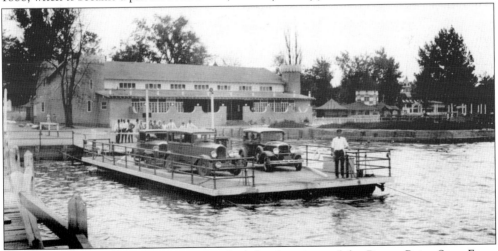

In 1926, the Celoron-Fluvanna Ferry was built by the owner of the Bemus Point-Stow Ferry, Alton Ball. It serviced residents of Celoron and across the lake at Greenhurst for nearly 10 years before the profitless venture was sold to the Chautauqua Lake Yacht Club in Lakewood for use as a floating dock. The *Greenhurst*, *Celoron*, and *Chadakoin* were used as charter taxis. Originally used for Lake Michigan excursions at the 1893 Chicago World's Fair, they were featured again at Buffalo's Delaware Park lagoon during the 1901 Pan American Exposition. Purchased by the Broadheads and brought to Chautauqua Lake to supplement the Jamestown Street Railway service, they carried passengers between Celoron, Greenhurst, Griffith's Point, and Lakewood. (Courtesy Mary Jane Stahley.)

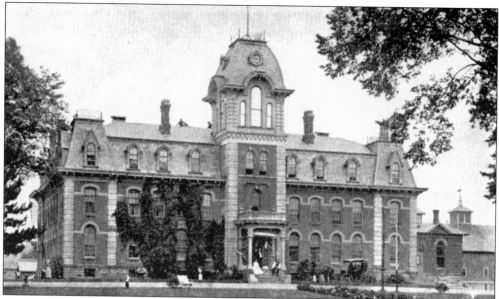

Prior to 1832, indigent residents of Chautauqua County were relegated to boarding with families or living with caretakers in rented rooms scattered around the county. To accommodate these literally poor souls, the county built a combination almshouse and asylum in Dewittville. The elegant administration building, above, with its asylum, hospital, and horse barn, provided comfort and care for the county's "mentally ill, the defective, orphan children [and] the needy aged." A former Dewittville teacher recalls that the "inmates" were not only well cared for but seemed peaceful whenever she saw them sitting on benches under the beautiful trees. (Courtesy Mary Jane Stahley.)

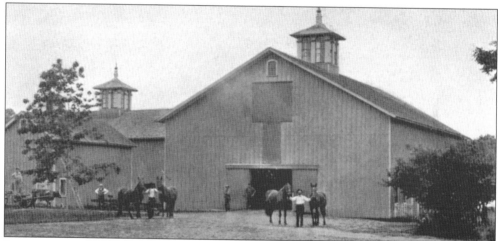

Inmates were allowed to engage in chores on the 306-acre farm. Whether shucking corn, feeding the horses at this barn, quilting, sewing, or canning, active participation proved mutually beneficial for the institution and for boarders such as Jacob Lockwood, who lived there for more than 30 years. The home also provided numerous employment opportunities for nearby residents, who remember it as a good place to work. In 1961, the County Home was relocated to a new facility in Dunkirk on Lake Erie. The adjacent cemetery, the internment site of about 600 inmates from 1833 until 1864, was rededicated at a 2001 ceremony and is all that remains of the former County Poor Farm in Dewittville. (Courtesy Mary Jane Stahley.)

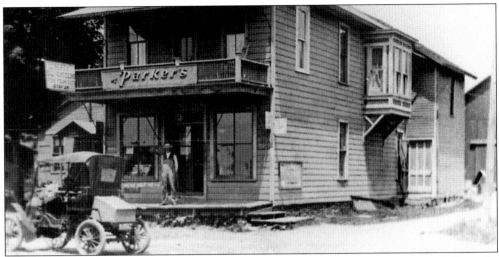

In 1805, Peter Barnhart (1751–1836), a soldier in the Revolutionary War, settled in the Hartfield-Dewittville area, on the east side of the lake between Mayville and Point Chautauqua. The property was originally purchased by Anson Leet, who settled at Leet's Point (now Point Chautauqua), as did his son William Leet. By 1870, the hamlet of Dewittville, aptly dubbed "Tinkertown," included not only a church, schoolhouse, and hotel but also shoemakers, coopers, gristmills, blacksmiths, sawmills, masons, carpenters, cheesemakers, and the first shop devoted exclusively to the production of axes. Dewittville was considered "old when Chicago wasn't even on the map" by the authors' grandparents. The general store, above, was owned by Clarence A. Parker, who also oversaw the Dewittville post office. (Courtesy Jane Currie.)

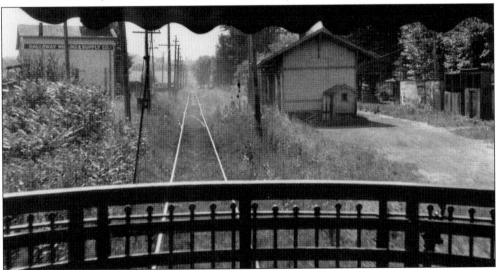

This c. 1940 view is from the observation platform of Car No. 312 as it leaves the Dewittville depot. At the left is the Galloway Mill, and coal sheds are near the railroad siding on the right. Manufactured in 1916 by the St. Louis Car Company, No. 312 was the most luxurious of the interurban cars of the Jamestown, Westfield and Northwestern railway fleet of electric trolleys, making two to three trips daily to connect with the finest New York Central trains. It was appreciated for its special comforts but, regrettably, in 1947, after 60 years of service, like the other trolleys, it was scrapped, cut up, and burned to be replaced by automobiles and improved highways. (Courtesy Chuck Hawley.)

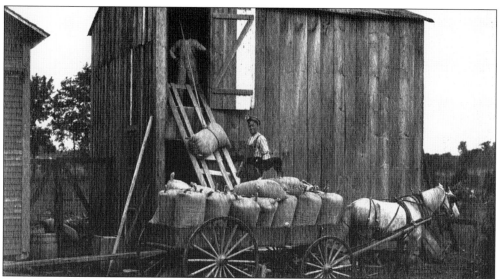

Residents of Maple Springs, like those in most early settlements, were hardworking individuals who supported their families by physical labor. In addition to the Becker brothers' farm and fishponds, farmers planted tobacco and tended vineyards in the area. This early-1900 photograph captures Raymond Scofield in the doorway of a feed mill storage building with George Stowell helping to lower at least a dozen full feed bags onto the wagon prior to delivery. Lifelong Maple Springs resident Maurice C. Bosworth recalled that he "used to drive a team of horses right out [to the steamer dock], turn the wagon around on the end, and load freight and baggage . . . and deliver trunks [to the boarding hotels and hotels]." (Courtesy Chuck Hawley.)

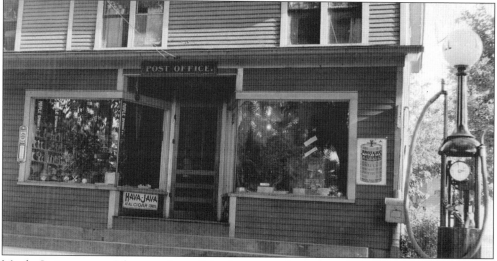

Maple Springs, one of the most beautiful colonies on the upper east side of the lake, has been a favorite address for many years. Proudly displaying Maple Springs pennants in the window, this combination general store-gas station-apartment, built on property once owned by the Broadheads, also served as the community's post office. When the latter opened in 1904, the steamboat dock, which had been midway between Point Whiteside (formerly Camp Collins) and Maple Springs, was relocated to avoid having two stops so close together. The communities combined to form a single steamboat dock at Midway and, in time, confusing as it may seem, Maple Springs became the official name of this quiet hamlet. (Courtesy Sydney S. Baker.)

Three

CHAUTAUQUA INSTITUTION AND POINT CHAUTAUQUA

The Chautauqua Institution had its beginnings on August 4, 1874, at Fair Point, on the west shore of Chautauqua Lake near Mayville. The Chautauqua Assembly cofounders, Lewis Miller and John Heyl Vincent, were both involved in the Methodist ministry in the late 19th century. Aware that Sunday school instruction was invaluable to the common man, they recognized the need for more competent Sunday school teachers.

Once their program was developed, Miller and Vincent deliberated over an ideal location for their summer studies. The businessman and preacher sought the perfect environment for teachers and students to meet to exchange ideas. Miller chose an outdoor setting of natural beauty already familiar to him, property belonging to the Methodist Episcopal Church at Fair Point, later renamed Chautauqua.

The Chautauqua community has been inspired by Miller's choice of setting, "one with the open air and the deep woods, 'the mystical ways of nature.'" Its extensive shoreline and its pure spring water were important to the cofounders, who thought the peaceful setting in a grove of native trees, with the forest's aroma and the songbirds' tunes, provided the ideal background for the original two-week intensive course of study. The other favorable feature of Fair Point was its proximity to major cities, villages, and towns, and the reliable railroad and steamboat connections that eventually made it accessible as well as idyllic.

Chautauqua's original mission was more effective religious education training, comparable to the normal school preparation for public school teachers, all for the betterment of society. In time, Miller and Vincent masterminded what evolved into a vigorous movement in popular education in America. The Chautauqua Movement promoted intelligence and culture, embracing cofounder John Heyl Vincent's original concept of Chautauqua: "All Things of Life . . . Art, Science, Society, Religion, Patriotism, Education . . . whatever tends to enlarge and ennoble."

By 1900, educators and ministers were joined on the Chautauqua platform by politicians,

authors, and other credible, qualified, and respected thought provokers from every phase of society. Following World War II, under the leadership of Chautauqua Pres. Arthur E. Bestor, the Chautauqua Institution became internationally renowned for the caliber of its presentations and presenters and for its performances and performers.

Although the name Chautauqua is synonymous with the educational and cultural establishment and has expanded beyond the original settlement, the Chautauqua Institution continues to be a delightful summer resort and a haven for several generations of lifelong learners. It has remained a vibrant educational and cultural mecca while maintaining its early traditions and values for over 128 years, during which it has hosted an impressive array of distinguished residents and guests.

Meanwhile, in 1817, pioneer Anson Leet purchased from the Holland Land Company 106 acres of land overlooking Dewittville Bay, three miles east of Mayville. In 1875, several of his Baptist descendants bought his property and renamed the site Point Chautauqua. The Point Chautauqua Baptist Union then proceeded to develop a Bible camp directly across the lake from its counterpart, the Chautauqua Assembly, begun by Methodists at Fair Point the previous year.

Like the Chautauqua Assembly, Point Chautauqua was selected because of its desirable location, as expressed by Rev. R.B. Hull in an 1884 Baptist Union paper: "there can be no more delightful place than a cottage upon the sunny slopes of this crystal, hill-locked lake. Here at once is repose and refreshment, solitude and inspiring associations." P.S. Henson, D.D., from Chicago praised Point Chautauqua in another 1884 Baptist publication, proclaiming it to be a "national denominational summer resort, where the eye shall revel amid romantic scenery, the brow is fanned by the most delicious and invigorating airs . . . the mind refreshed and refurbished by lectures and essays, sermons and addresses . . ." He continued that "it does look as if our Baptist Chautauqua, by virtue of its inherent and overmastering attractiveness . . . is bound to achieve great success, and be more and more a summer Baptist mecca, to which tired pilgrims . . . shall rejoicingly resort."

Although it was hoped that charity and brotherhood would bond Baptists from different and distant locales during the summer months at Point Chautauqua, the organizers of this "second Chautauqua" overextended themselves financially and found that their second season, in 1876, was poorly attended. As a result, by the end of the 1880s, the Baptist colony was disbanded and Point Chautauqua became a secular summer resort colony. It is this delightfully unique residential community that is the focus of this chapter, along with several distinguished residents and guests at the Chautauqua Institution across the lake.

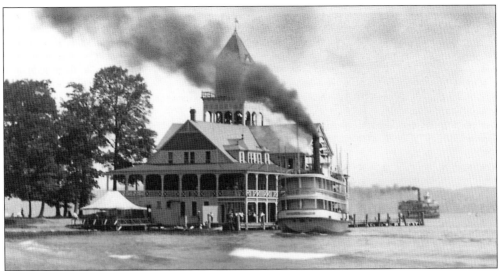

Lakeside hotels, including the fashionable Athenaeum Hotel and numerous boardinghouses at the Chautauqua Institution, depended upon the steamboat lines for delivery of not only their clientele and luggage but also their food and other provisions, supplies, and mail. In addition, the Chautauqua Assembly dock was used by the *Mayville* and the *Chadakoin*, small steamers that ferried passengers back and forth between Chautauqua and the Pennsylvania Railroad depot in Mayville. Popular sunset rides also originated at the dock. (Courtesy Jane Currie.)

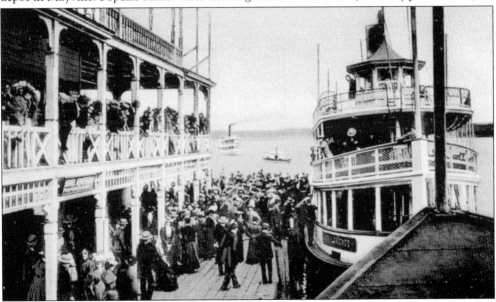

Prior to the establishment of the Chautauqua Traction Company trolley service to the Chautauqua Assembly, most excursionists arrived by steamboat. Built in 1886 to accommodate the increasing number of visitors, the Pier Building's waiting room, ticket and baggage office, and sundry shops were among the first stops for guests. Exhausted from their travel and anxious to get settled into their summer residences, the guests understandably wanted to retrieve their personal belongings as quickly as possible. However, when the steamer *Jamestown* landed with about 200 passengers and was followed 15 minutes later by the *Mayville* with 150 more, patience was imperative. (Courtesy Gene Smith.)

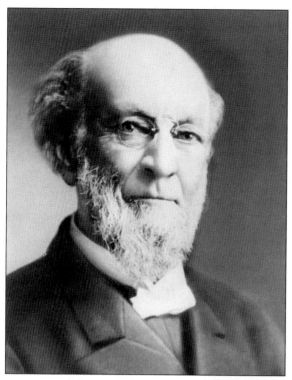

John Heyl Vincent (1832–1920), cofounder of the Chautauqua Assembly, is remembered as an inspirational and eloquent religious leader. Announcing the Chautauqua Literary and Scientific Circle (CLSC) in 1878, known as "the oldest continuous book club in America," Vincent enabled readers of both sexes and a wide range of ages and occupations to gain the education they craved. Fostering the habits of reading and study in connection with the routine of daily life, the Chautauqua culture quickly spread, and Vincent's name became "a household word from the Atlantic to the Pacific." Chautauqua Pres. Arthur E. Bestor believed that Vincent "contributed more than any other man of his generation to the enlightenment of thousands of human beings." (Courtesy the Chautauqua Institution Archives.)

Lewis Miller (1829–1899), a respected industrialist, Sunday school superintendent, inventor, and educator, cofounded the Chautauqua Assembly. In John Heyl Vincent's *The Chautauqua Movement*, published in 1886, he praised his partner's "devotion to education, his inventive genius, business capacity, and well-known liberality [which] promised from the beginning large success to Chautauqua." Of significance, also, is Miller's introduction to the same book, in which he extols his own philosophy of the foundation of the Chautauqua Institution: "The churchman, the statesman, the humanitarian, must be brought on [Chautauqua's] platform, and, there, free from caste and party spirit, discuss questions, solve problems, and inaugurate measures that will mould and inspire for the right." (Courtesy the Chautauqua Institution Archives.)

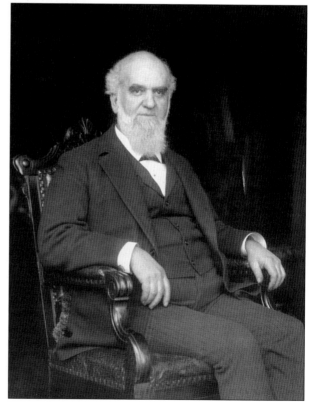

Best known as the social reformer who founded Chicago's Hull House in 1889, Jane Addams (1860–1935) was beloved by Chautauquans. An ardent suffragette, she served on Chautauqua's Educational Council for many years and was a frequent speaker on the lecture platform. Her publications *Newer Ideals in Peace* (1907) and *Twenty Years at Hull House* (1911) were chosen as selections for the Chautauqua Literary and Scientific Circle home reading list and, thus, were read by thousands of enrollees in the program. She was named the honoree of the CLSC Class of 1915, the "Jane Addams Class." In this Recognition Day photograph, she is seen with founder John Heyl Vincent, on the left. (Courtesy the Chautauqua Institution Archives.)

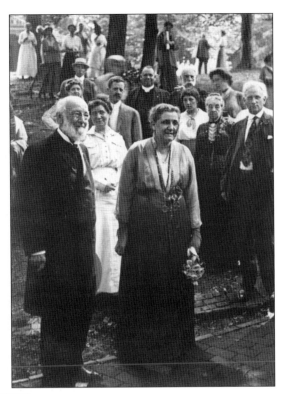

Hired by Theodore L. Flood, editor of the *Chautauqua Assembly Herald* and the *Chautauquan*, Ida Tarbell (1857–1944) prepared study aids for readers enrolled in the CLSC course of study. In addition to her daily columns, the Allegheny College graduate, whose family had summered at the Chautauqua Assembly, began to examine what she deemed society's evils. After leaving Chautauqua, she relentlessly pursued and exposed the political corruption of the Standard Oil Company monopoly and, as a result, she is heralded as the inventor of modern investigative reporting. (Courtesy the Chautauqua Institution Archives.)

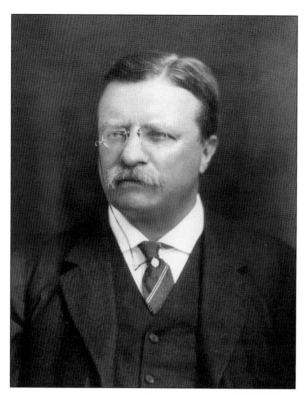

In anticipation of Pres. Theodore Roosevelt's visit to the Chautauqua Assembly in 1905, special excursions were scheduled for the steamboats and railroads. Prior to Roosevelt's address, "Popular Education and Democracy," members of the School of Domestic Science catered a breakfast at Higgins Hall for the presidential party and dignitaries. Cottages were decorated, the procession route was published beforehand in the *Chautauqua Assembly Herald*, and every effort was made to keep the Chautauqua Amphitheater stage as "distinctively Chautauqua as possible." The only other sitting president to have honored Chautauqua at that time was Ulysses S. Grant, who came to the second Chautauqua Assembly in 1875. (Courtesy the Chautauqua Institution Archives.)

Williams Jennings Bryan (1860–1925) was an eloquent orator whose international reputation made him a sought-after speaker on the Chautauqua circuit. He was a member of the Lincoln, Nebraska, Chautauqua reading course and a member of the Chautauqua Literary and Scientific Circle Class of 1891. In 1907, his lecture topic at Chautauqua was "The Old World and Its Ways," in keeping with his reputation as a keen observer of the American social and political scene. In one of his first lectures during the Democratic presidential campaign of 1912, Bryan contended that a campaign speech did not violate the proprieties of Chautauqua because its platform was renowned for catering to every human interest. (Courtesy the Chautauqua Institution Archives.)

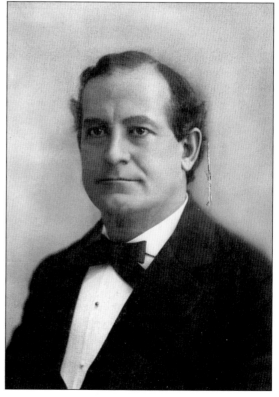

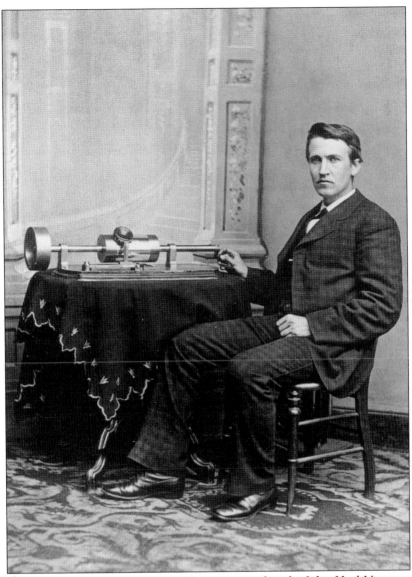

While residing in Plainfield, New Jersey, Chautauqua cofounder John Heyl Vincent attended a phonograph demonstration at nearby Menlo Park, the site of inventor Thomas Edison's laboratory. Although Thomas Alva Edison (1847–1931) did not immediately accept Vincent's invitation to visit the Chautauqua Institution, once there, several years later, he literally became part of the Chautauqua family when he married cofounder Lewis Miller's daughter Mina in 1886. Biographer Neil Baldwin relates that Edison went there "ostensibly to demonstrate the phonograph, but [was] lured equally by the promise of quiet evenings in a meditative setting overlooking the tranquil lake." Edison is known and admired worldwide for an unprecedented 1,000-plus patents and his remarkable inventions, including the incandescent light bulb, the motion picture camera, and the phonograph. The latter is captured in this Matthew Brady photograph. Chautauquans, however, knew this progressive visionary as an asset to their summer retreat and for his involvement in the success of the Chautauqua Movement. In 1930, he was a graduate of the Chautauqua Literary and Scientific Circle, as well as its honoree. (Courtesy the Chautauqua Institution Archives.)

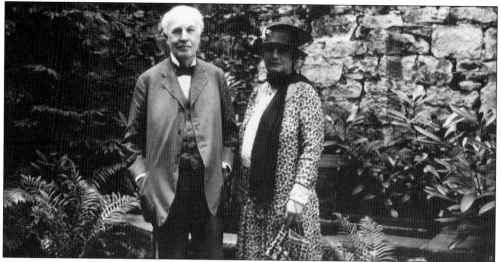

Thomas Edison and his second wife, Mina, posed for this photograph in the Miller Garden, which remains intact today behind the Miller Cottage at the Chautauqua Institution. It was designated as a National Historic Landmark in 1969. During their 45-year marriage, the couple were active Chautauquans. Mina Edison, the self-proclaimed "home executive," was a passionate conservationist and played an integral role in the Chautauqua Bird and Tree Club, whose name was expanded to the Chautauqua Bird, Tree, and Garden Club. She also served on many boards including the National Audubon Society and the Chautauqua Institution. (Courtesy the Chautauqua Institution Archives.)

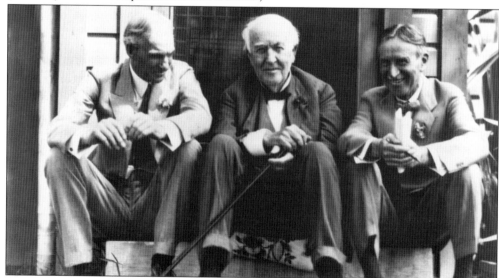

Seated on the left of Thomas Edison is automotive pioneer Henry Ford (1863–1947), who met the inventor in 1896 at a Long Island convention, greatly admired him, and hoped that he might design certain parts for the Model T. Ford. Because of their growing friendship, Ford was a frequent visitor to Chautauqua. Ford's other connection to the grounds was through Edison's father-in-law, Lewis Miller, since he had once been the Michigan sales representative for Miller's invention, the Buckeye mower and reaper. The Henry Ford Museum in Dearborn, Michigan, which honors great achievements, includes Edison's Menlo Park laboratory. The man at the right is possibly Harvey Firestone. (Courtesy the Chautauqua Institution Archives.)

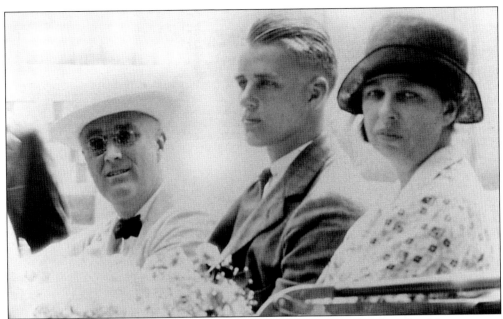

In 1929, New York Gov. Franklin D. Roosevelt (1882–1945) spoke about health care to an audience of over 4,500 at the Chautauqua Amphitheater. He was accompanied in this Packard touring car by his son Elliott Roosevelt, his wife, Eleanor Roosevelt, and his secretary Gurney T. Cross, as they visited the newly built Norton Hall prior to his address. Eleanor Roosevelt (1884–1962) was adored by Chautauquans and made several appearances at the Chautauqua Amphitheater and the Chautauqua Women's Club. She found Chautauqua "particularly interesting [because] . . . the whole family may fulfill each his own desires and interests and yet can be together." (Courtesy the Chautauqua Institution Archives.)

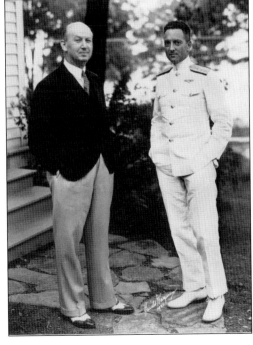

Intent upon educating Chautauqua audiences on myriad topics, Pres. Arthur E. Bestor served the Chautauqua Institution for over 40 years and hosted dignitaries from all walks of life. In August 1931, Antarctic explorer Rear Adm. Richard E. Byrd, seen to the right of Bestor, addressed a record crowd of 8,000, standing 10 deep around the Chautauqua Amphitheater's perimeter. The U.S. Naval Academy graduate, navigator, and aviation authority captivated his audience with a combination speech and motion picture presentation of his personal experiences in "Little America." "The Flight to the South Pole" was shown on a large screen hung in front of the organ pipes and, for the first time, loudspeakers were used so that he could be heard by everyone attending. (Courtesy the Chautauqua Institution Archives.)

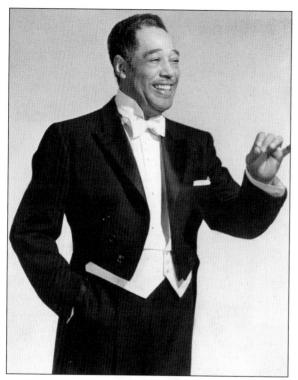

Chautauqua cofounders Lewis Miller and John Heyl Vincent intended that music be incorporated into the Chautauqua concept for religious accompaniment and, also, for recreation and entertainment. Sacred music at meetings in the grove and fine bands from Mayville and Meadville, Pennsylvania, were an integral part of the early assemblies. Years later, Ralph H. Norton, a former Chautauqua Institution president, noted that Chautauqua provided "a veritable feast for the music lover." Symbolic of the caliber of performers who have appeared on the Chautauqua stage, Duke Ellington, left, was invited to open the 1972 season. Chautauqua is unique in that it has its own symphony, opera, and theater companies, in addition to its impressive list of musical guests. (Courtesy the Chautauqua Institution Archives.)

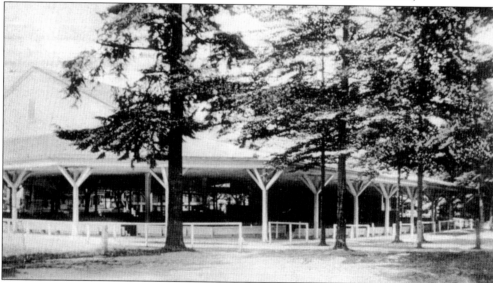

The majority of visitors to the Chautauqua Institution attend lectures, musical programs, and/or ecumenical worship services at the centrally located Chautauqua Amphitheater on the Brick Walk near Bestor Plaza. The original structure was in the gorge but was replaced by this well-known community gathering spot in 1893. Following the installation of the Massey Memorial Organ in 1907, the renovated "Amp," with its increased seating capacity, improved acoustics, and unimpaired viewing, assumed greater stature on the grounds. Presidents and preachers alike have used Chautauqua's podium to enlighten appreciative audiences, who represent a wide range of interest, viewpoints, and tastes. (Courtesy Gene Smith.)

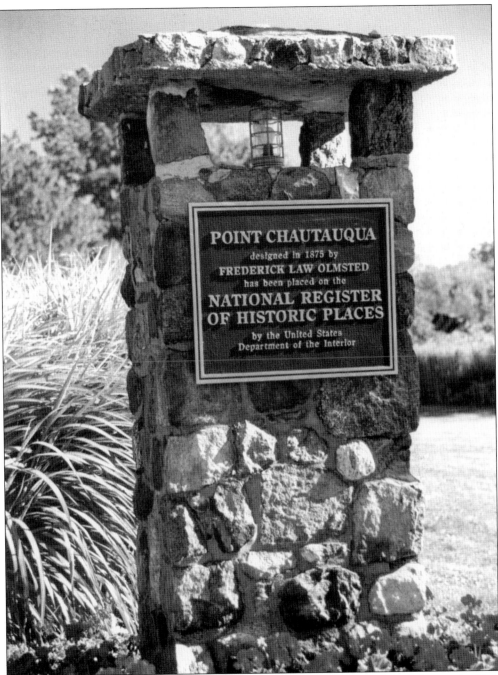

The entrance to Point Chautauqua, located on the eastern shore of the lake overlooking Dewittville Bay, is well marked. Affixed to the stone pillar is a plaque indicating the community's designation on the National Register of Historic Places. Awarded by the U.S. Department of the Interior in 1996, the plaque commemorates famed landscape designer Frederick Law Olmsted's unique design of the one-time religious colony more than 100 years earlier. Although not a gated community, one of Olmsted's aims was to create an escape retreat from the hustle and bustle of urban life. (Courtesy Jane Currie.)

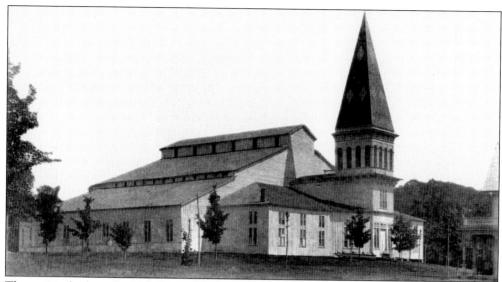

The original plans for the Point Chautauqua community emphasized gathering areas for religious activities. In the late 1870s, the Hartson Tabernacle, with its 134-foot spire, occupied an imposing location at one of the highest points on the grounds. Its large stage and seating capacity of 5,000 were used for entertainment purposes when religion was no longer the community's focus. It was converted to a Temple of Music for summertime visitors until it was razed in 1904. (Courtesy Sydney S. Baker.)

This photograph is indicative of the strategy employed in landscape architect Frederick Law Olmsted's design. Because of his dissatisfaction with the layout of the Chautauqua Assembly grounds, Olmsted created a different and, to his mind, a better model to avoid overcrowding, excessive shade, and sanitation problems. Horse-drawn carriages and pedestrians had ample space to easily maneuver the gently graded slopes on tree-lined roads to shop or attend gatherings. (Courtesy Sydney S. Baker.)

Eminent landscape artist Frederick Law Olmsted (1822–1903) was commissioned by the Baptist Assembly to design the summer colony at Point Chautauqua. Inspired by several visits to Europe, Olmsted realized the need for public parks and designed some of the finest in the United States: Central Park in New York City, Prospect Park in Boston, Yosemite National Park, and some of smaller scale in Chicago and Buffalo. Although he is probably best known for his layout of the U.S. Capitol grounds, an especially interesting creation is called the Emerald Necklace, a system of parks and parkways in Boston. In every locale, Olmsted, the visionary, capitalized on the site's natural amenities and used them to advantage. In the 20-acre sloping grove at Point Chautauqua, he emphasized space, shade trees, flowers, fountains, and miles of winding roads. The Point Chautauqua Tabernacle, open-air pavilion, and residential section occupied the higher areas, while places of assembly and social activity, such as the Corinthian and Sylvan groves, were located downhill. This latter common area was specifically designed to create a sense of community and unity among neighbors. (Courtesy the National Park Service, Frederick Law Olmsted National Historic Site.)

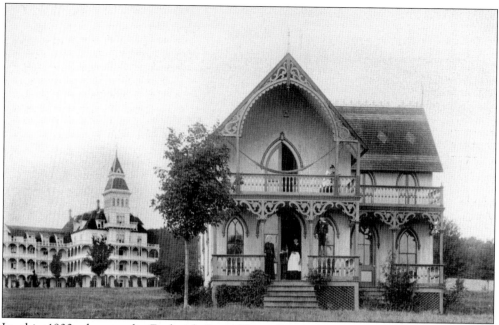

In this 1900 photograph, Frederick Law Olmsted's emphasis on space is obvious. The Grand Hotel, in the background, appears to be quite distant from the ornately decorated Victorian home, the former residence of one of Point Chautauqua's postmasters. (Courtesy Sydney S. Baker.)

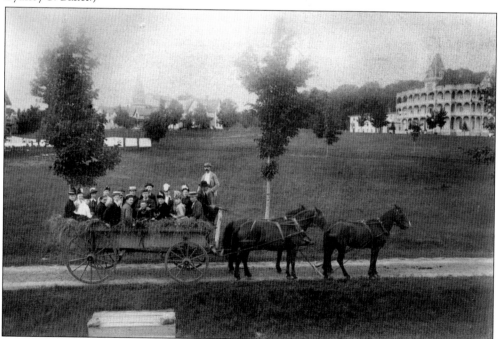

Again in this photograph of children enjoying a hayride, overcrowding is not an issue. A variety of individual and family activities was available at Point Chautauqua. One could roller-skate, bowl, bicycle, ride, and dance; play billiards, golf, and croquet; and attend concerts and theater productions. (Courtesy Sydney S. Baker.)

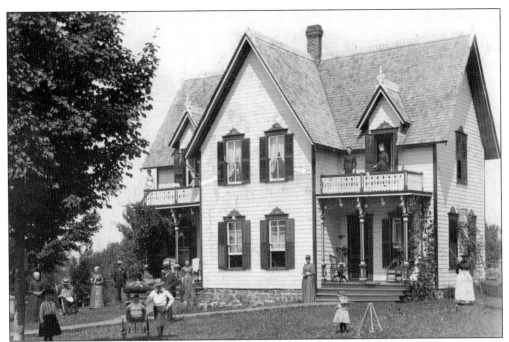

Sometimes called the Jackson Cottage, this private residence, located at the corner of Emerald and Floral Avenues, was the home of Ward Cadwell, front left. Pictured in the late 1800s, it is thought to be the third house built at Point Chautauqua. (Courtesy Jane Currie.)

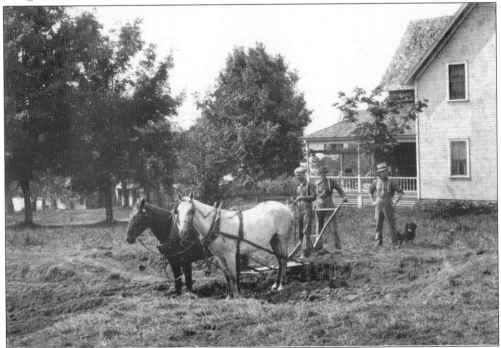

Ward Cadwell, easily recognized by his same stance as in the top photograph, designed and constructed many homes in Point Chautauqua. In this 1899 photograph, he is using a team of horses to break ground for yet another house. (Courtesy Jane Currie.)

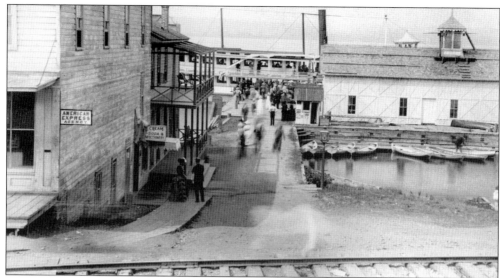

Grand Hotel manager J.E.H. Kelley lured guests to his Point Chautauqua hostelry by advertising that "the lake is cleaner to bathe in than a porcelain lined tub . . . and that the fishing . . . would stir the sportsman's soul . . ." Thus, Point Chautauqua was one of the steamship line's busiest landings. The dock building housed a ticket and baggage office, shops, a post office, an American Express office, and the Jamestown, Westfield and Northwestern trolley station. Also near the landing were the boat livery, bathhouses, bowling alley, and ice-cream and refreshment stand. Note the rail line tracks in the foreground. (Courtesy Sydney S. Baker.)

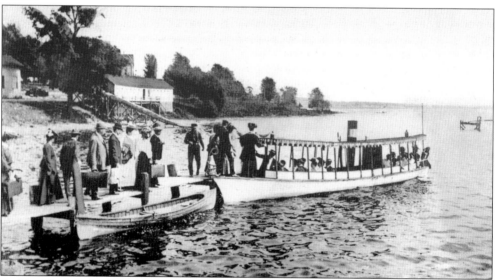

Builder Ward Cadwell doubled as a baggage master, unloading heavy trunks and cases to deliver to hotels, cottages, and boardinghouses. It was a 10-minute journey from Point Chautauqua across the lake to the Chautauqua Institution for vacationers who enjoyed the latter's cultural offerings but not its Sabbath and prohibition restrictions. However, ferry service proved more popular. By 1925, when the *Chadakoin* was removed from service, only the *City of Cleveland* and the *Mayville* were used on the triangular route from the Point to Mayville to Chautauqua and back. (Courtesy Jane Currie.)

Four

HOTELS

Served directly by the trolley lines and lake steamers, many at their own docks, innumerable hotels dotted the shores of Chautauqua Lake in its heyday. Local columnist Patricia Parker called them "popular resorts for sophisticated travelers." And so they were in the early years; unlike contemporary hotel-motel chains, each hotel or inn boasted unique features and individualized service for the excursionists to the Chautauqua Lake region. Competition was fierce, so each provided the best it could offer.

Nearly all of the well-remembered hostelries were located either lakeside or advertised commanding lake vistas, many with lawns sloping down to the water's edge. All of them touted the Chautauqua region's advantageous climate, gentle breezes, pure clear water, tranquility, picturesque surroundings, and attendant opportunities. Relaxation and recreation headed their lists; rocking chairs on large verandas, tennis courts, croquet, bathing, boating, fishing, dancing, parties, fine cuisine, modern facilities, and personalized service by congenial proprietors and staff were deliberate enticements for tourists.

Accompanied by servants, visitors brought steamer trunks jam-packed with a season's worth of stylish evening gowns and tuxedos for not-so-formal occasions by today's standards. Two-to-three-hour dinners were commonplace, and social activities ran the gamut from dancing to concerts to sunset cruises.

Depending upon the size and needs of lakeside communities, the number of available accommodations obviously varied. If on the grounds of the gated Chautauqua Institution community, visitors could book themselves into small boardinghouses, denominational houses, or family-run hotels; the wealthy and elite, however, opted for the prestigious Athenaeum Hotel, with its exceptionally fine amenities. Hotels in the communities of Lakewood, Bemus Point, and Mayville were usually filled to capacity, and several were needed at each site.

Of interest is the fact that the various Chautauqua County villages catered to different strata of society. The elegant hotels in Lakewood attracted socially prominent individuals and families; Bemus Point vacationers found the row of family-style hotels near the ferry to their

liking; and Mayville, the county seat, served the needs of politicians, government officials, and others who traveled there for business transactions.

Viewed from the steamer decks, the sprawling hotels with their beautiful lawns and colorful flower beds—especially on the Lakewood shoreline—were most impressive. Cottages were built near these large hotels to increase services and accommodate the overflow. Families also wanted more privacy and yet wanted to take their meals and socialize with those staying at the hotels. Both the hotels and cottages were filled to capacity during the summer season to house "the eager throng."

With the advent of modern transportation, which enabled families to venture to different vacation destinations, the lake hotels, like the lakeside parks, disappeared due to decreased patronage. If not destroyed by fire in the 1920s or 1930s, they were deliberately destroyed. Only two hotels of that era remain as testaments to former days of glory: the Athenaeum Hotel at the Chautauqua Institution and the family-owned Hotel Lenhart at Bemus Point. Decades later, both are as charming and hospitable as ever—perhaps even more so.

Returning summer visitors find the signature rockers on the Hotel Lenhart porch a welcome sight. Spectacular Chautauqua Lake sunsets seem even more wondrous from this vantage point. (Courtesy Jane Currie.)

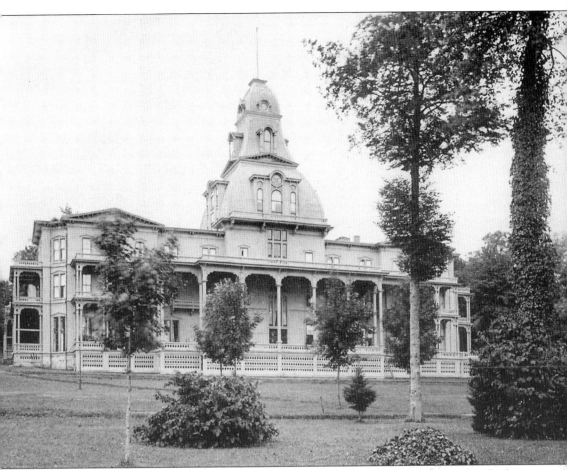

This is a bare-bones view of the Athenaeum Hotel, the grande dame of lakeside hotels, which opened in 1881. Stockton architect William Worth Carlin, appreciative of the Swedish craftsmen in Jamestown, had lumber prepared there and shipped up the lake to the Chautauqua Institution site. Upgrading their accommodations from the rudimentary tents and the crude Palace Hotel, guests delighted in the numerous amenities, including a telegraph office, a newsstand, electric bells to summon assistance, and an elevator. Because of Edison's connection to Chautauqua, the hotel was one of the first public buildings to be equipped with electric lamps. The Athenaeum's interior elegance—high-ceilinged parlors adorned with crystal chandeliers, grand staircase, spacious lobby, and well-appointed rooms—was equally matched by its impressive exterior. Unlike the image above, the hotel bustled with activity on its expansive veranda, where guests enjoyed an unobstructed view of the lake while dining or relaxing. The obvious change is the removal of the top towers in 1923 due to their excessive weight. Service today, however, remains first-class; the management and staff cater to experienced travelers from all over the world. (Courtesy Sydney S. Baker.)

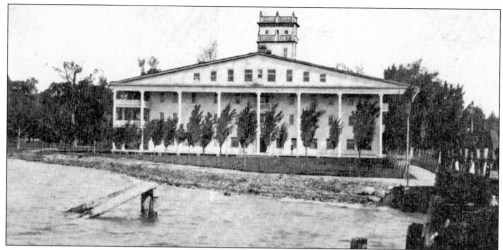

A popular lakeside resort in the late 1870s, Sheldon Hall, opposite Lakewood, was owned by Porter Sheldon, a pioneer in the photographic paper industry in Jamestown. Built almost on the exact site of the former Griffith's Point Hotel, property owned by the Sheldon family, Sheldon Hall had its own steamboat dock and, thus, was accessible to visitors. The neat white-columned mansion was closed in 1920 and, typical of other Chautauqua Lake landmarks, was razed when patronage decreased as automobiles enabled visitors to seek divergent recreation spots. Today, its replacement, a popular summer bed-and-breakfast establishment, unique on the lake, continues to be a Sheldon family enterprise. (Courtesy Kathleen Crocker.)

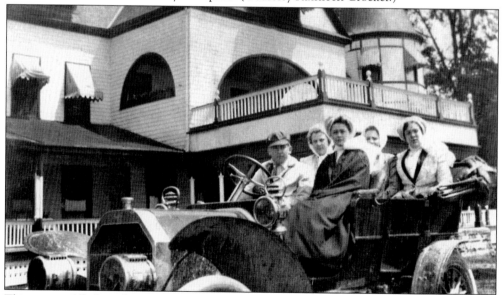

This tourist-filled roadster is situated in the driveway of the Greenhurst Hotel, built by Jamestown attorney Eleazer Green in 1889, after the original 1872 annex. Anticipating the rail system and post office, the owners developed the Victorian building into an elaborate resort, easily recognized by its green-and-white awnings and ornamental tower. Accessible by steamboat at its long dock or by ferry steamers crossing to Lakewood and Celoron, this popular resort was owned by Lucia Scarpino from 1928 to 1938. To supplement the hotel's income, the neighboring Chadakoin Crew Club was welcome to use the hotel's facilities for their social center. Sadly, fire claimed the hotel in 1938. (Courtesy Thomas Scarpino.)

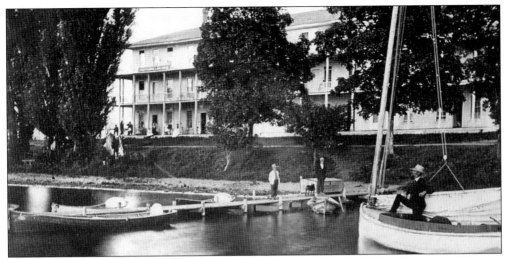

These two unique views of the Pickard House permit the reader an opportunity to envision the changes that transpired when the hotel was joined to the adjacent Hotel Browning and Columbia Inn in 1920. The entire complex became the Columbian Inns, in commemoration of the 400th anniversary of Columbus's voyage to the New World, featured at Chicago's Columbia Exposition. James Selden, a Pittsburgh tycoon, bought the inns in 1930 from the Rappole family and had them demolished in order to build an entertainment complex, which never materialized due to his untimely death. The Surf Club, one of the hot spots on the lake, now occupies that coveted corner. (Courtesy Kathleen Crocker.)

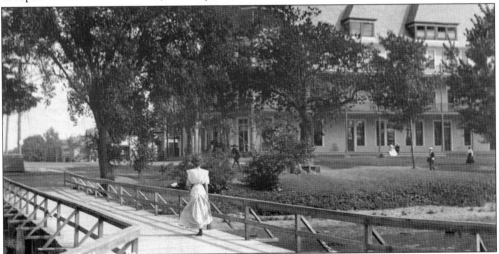

The corner of Main Street and Lakeside Drive in Bemus Point has been an ideal location since the Chautauqua Lake House was built there in 1875. After that establishment was destroyed by fire, Andrew J. Pickard in 1889 renamed its replacement the Hotel Pickard, or Pickard House. Enjoyed for its freshly caught lake dinners and fiddlers, the hotel inevitably grew. In 1916, the hotel's second-and-third story verandas were removed and a one-story columned porch was built, maintaining the more than 60 lakefront windows while offering a more elegant look on the 150-foot water frontage. H.B. Sullivan, who later operated the Portage Inn in Westfield, assumed proprietorship from 1917 to 1919, advertising in Pittsburgh newspapers the hotel's homelike atmosphere and his innovative feature: the serving of dinners at noontime rather than in the evening. (Courtesy Kathleen Crocker.)

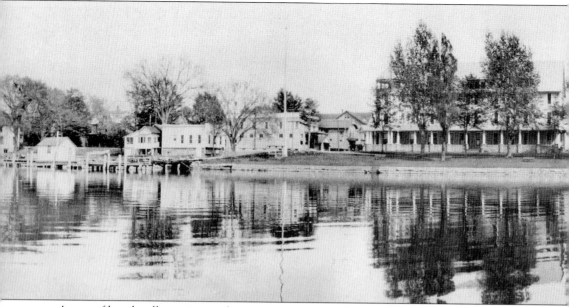

A row of hotels, all catering to the growing tourist trade, once lined Lakeside Drive in Bemus Point, as this 1916 panoramic view clearly indicates. At the far left is Lawson's boatyard and then Ward's ice-cream parlor at the corner of Main Street and Lakeside, where the steamers once docked. Next, from left to right, are the large Pickard House, the Columbian Inn, the Hotel Browning, the Hotel Lenhart, the village park, the Casino, and the ferry landing. In 1920, the Columbian Inn and the Hotel Browning were combined. After the Hotel Browning

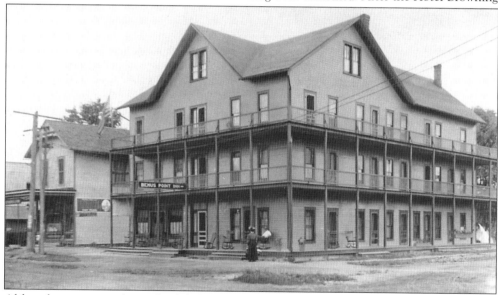

Although not situated on the lakefront, the Hotel Rappole, at Main Street and Maple Avenue across from the Bemus Point Library, has had its share of success like those closer to the dock and ferry. From the original American House in 1880 to its use as a ballroom and theater to the present-day See-Zuhr House Restaurant, thousands of local residents have joined area visitors at this gathering spot, enjoying its friendly informal atmosphere year-round. (Courtesy Jane Currie.)

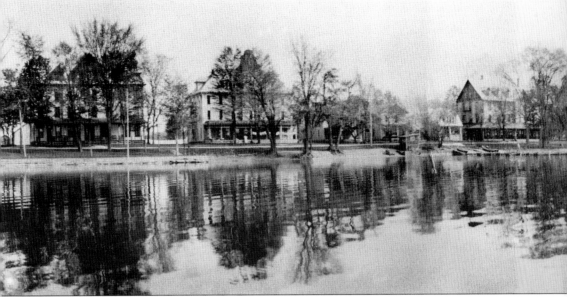

burned in 1941, that property was purchased by Victor Norton Sr. and his son. Many visitors fondly remember renting Norton's summer cabins and bicycles built for two. Each hostelry had several adjacent buildings used for laundries, icehouses, storage, and staff quarters. In 1891, one of the hotels sensibly added a separate facility for children and their nannies for use as an indoor playroom during the inclement weather. (Courtesy Kathleen Crocker.)

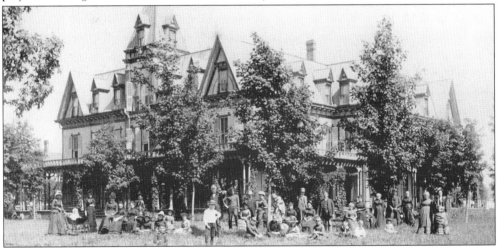

Several families pose on the front lawn of the original Hotel Lenhart, built in 1881 by horse-and-buggy doctor J.J. Lenhart. After the hotel burned to the ground nine years later, the present hotel was built fairly quickly and has remained in the Lenhart family for four generations. Much remains of its old world charm: claw-footed bathtubs, original furniture, the absence of central air-conditioning and heating, a roll-out cash register (credit cards are far too modern), and delicious home-cooked meals. Communication with the outside world is thought to interrupt or spoil one's leisure; access to the sole television is in the community parlor, and the one telephone booth is in the lobby. Yet, guests return year after year to savor the hotel's old-fashioned atmosphere, hospitality, serenity, and fabulous sunsets—made to order for Lenhart guests relaxing in the colorful rockers. (Courtesy the Johnston family.)

65

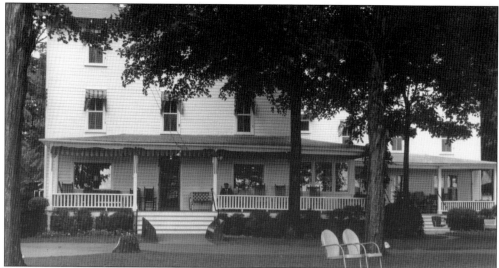

In 1874, a hotel was built midway between Point Whiteside and Maple Springs, complete with its own community steamer dock. Located on one of the most tranquil spots on the lake, it was an ideal summer vacationland, catering also to its year-round residents. Noted for its "electric lights, good bathing and good fishing," the Whiteside Hotel, a Maple Springs landmark, operated for several decades. It was purchased in 1959 by Spike Kelderhouse and his wife and, in turn, was sold to a builder, who razed the building and replaced it with condominiums. The hotel's closest competitor, the Maple Springs Inn, built in 1879, was owned by Perry Barnes. It was purchased in 1913 by two sisters of Jamestown's Broadhead family, who renamed their summer residence Harewood. (Courtesy Spike Kelderhouse.)

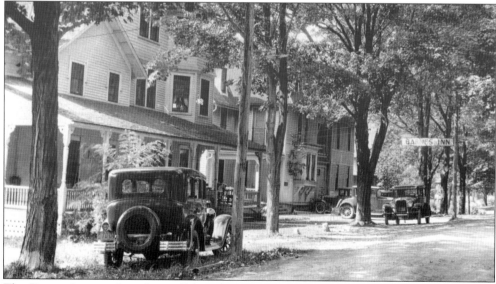

The Barnes Inn, a relatively small hostelry composed of adjacent buildings, was located at Point Chautauqua on Floral Avenue near the residential section. It was one of several busy summertime hotels and boardinghouses on the grounds. It burned in 1930. Another popular spot was the Inn at Point Chautauqua, located on a terrace overlooking the lake and patronized by local residents, especially old-timers who enjoyed its beer garden and its friendly and informal atmosphere. (Courtesy Jane Currie.)

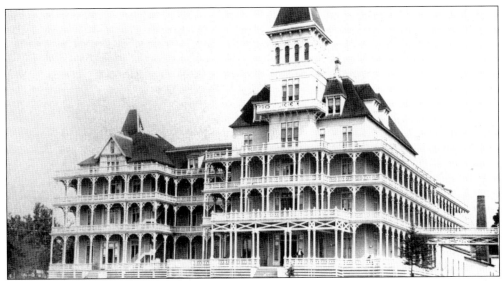

Aptly named, the Grand Hotel at Point Chautauqua, built in 1878, was the largest wooden hostelry on the lake for several years. Situated on a promontory with a commanding view, its front was nearly 250 feet in width, with a 130-foot center campanile. In 1902, the hotel was burned to the ground; nothing was salvaged. According to the Jamestown *Evening Journal* report of that event, "The destruction was as complete as if an earthquake had swallowed up the great building." The scandalous arson, attributed to the insurance greed of part owners, resulted in three lengthy trials and eventual imprisonment. Obviously, the loss of this magnificent structure had a damaging effect upon the economy of Point Chautauqua. (Courtesy Jane Currie.)

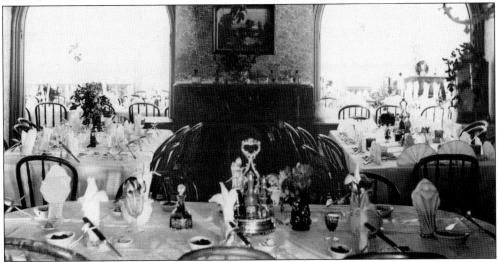

The deluxe Grand Hotel had features that rivaled those of the Athenaeum Hotel, built a year later directly across the lake at Fair Point, with its first-class passenger elevator, wraparound verandas, and capacity to accommodate 400 guests, twice the number of its competitor. The elegant formal dining room, seen above, was admired for its distinctive china and silverware; note the unique stance of the latter. No wonder many Jamestown High School alumni classes chose the Grand Hotel for the site of their reunions in the late 19th century. (Courtesy Sydney S. Baker)

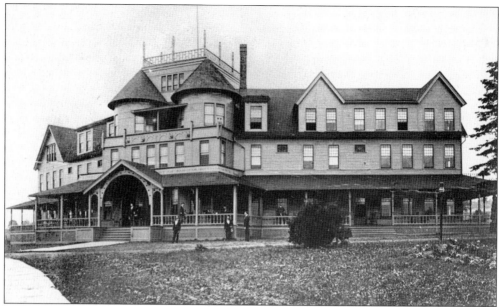

Located between Point Chautauqua and Mayville, this three-story edifice was initially used by Beta Theta Pi fraternity as the Wooglin Club, a summer resort for its members. Conventions were held there for nearly a decade beginning in the mid-1880s. When fraternity patronage declined, the club was converted into the Wooglin Inn and was operated as a hostelry until it was struck by lightning and burned to the ground in 1901. (Courtesy Jane Currie.)

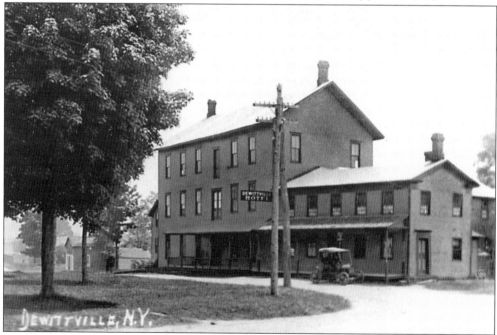

The Dewittville Hotel was built sometime before the 1920s and served several purposes. Part of the building housed the Dewittville post office, while another was designed as apartments for teachers who boarded there during the school week. It was also a restaurant and a dance hall. (Courtesy Jane Currie.)

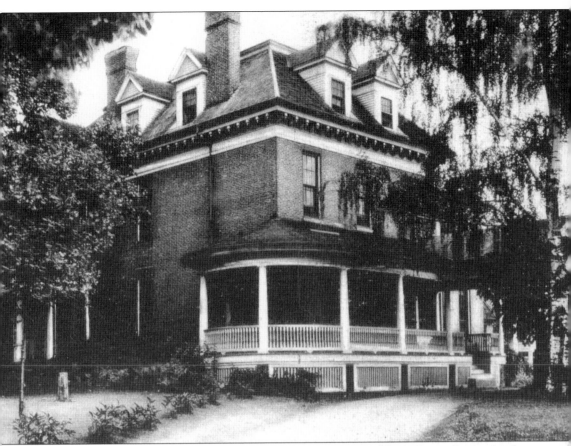

Mayville's famed Peacock Inn was the former home of Judge William Peacock, the local Holland Land Company agent. The Georgian-style Colonial mansion was touted as "a famous summer watering place" and for its "rational recreation and relaxation for both mind and body." In addition to the Indians who sought Peacock to discuss their land purchases, Mrs. Peacock hosted such dignitaries as William H. Seward and Daniel Webster; the latter visited local resident Donald McKenzie in 1841 to discuss a United States and Canadian boundary dispute. The homey atmosphere was appreciated by all guests, including the county fraternal, religious, political, and service organizations that held meetings there. The inn, located next to the courthouse on a promontory at the head of the lake, had a roof garden, which provided a commanding view. Because of its proximity to the traction line, railroad depot, and steamboat docks, its dining room and cocktail lounge were generally filled throughout its 150 years of operation. The Peacock Landmark Society made an unsuccessful attempt to preserve the inn, which was demolished in 1971 to become a parking lot for county officials and employees. Part of its iron fence remains, the only telltale sign of its existence. (Courtesy the family of Linda and Ira Davis.)

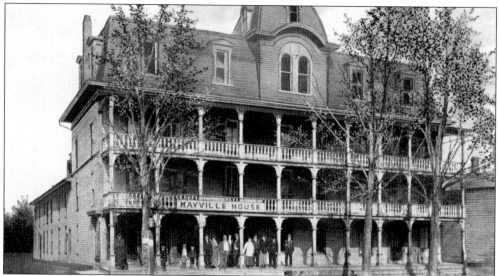

Built in the late 1800s, the four-story, mansard-roofed Mayville House, established by Horace Fox, was one of the oldest lake resorts. Located half a mile from the railroad depot in the village's business section, it was frequented primarily by politicians, judges, lawyers, jurors, and commercial travelers. In 1896, William Jennings Bryan campaigned on its porch. In 1914, a spectacular inferno of unknown origin forced guests to flee the building in their nightclothes. Reportedly, "the burning embers and sparks blew as far as the lake . . . [and only] . . . snow-covered roofs kept the fire from spreading." (Courtesy the Merle W. Scriven family.)

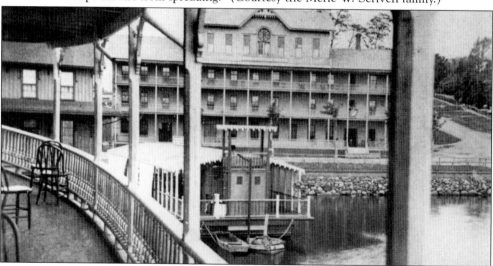

This view of the Chautauqua House was taken from the deck of the *Nettie Fox*, docked across the road at the Mayville landing. Along with the docks, the train depot at Mayville afforded easy accessibility; in fact, the 66-room hotel was constructed as part of the village's railroad venture. Once named Fox House for owner Horace Fox, who had previously managed its competitor pictured above, the hostelry doubled its capacity and, in 1880, the dock was also lengthened to facilitate the increasing numbers of visitors to the Chautauqua Assembly at nearby Fair Point. In an article of that era, Emma Dewhurst admonished her readers by writing that "if you want a better table than [Horace Fox] sets, you are an incorrigible epicure and Delmonico himself could not please you." (Courtesy Sydney S. Baker.)

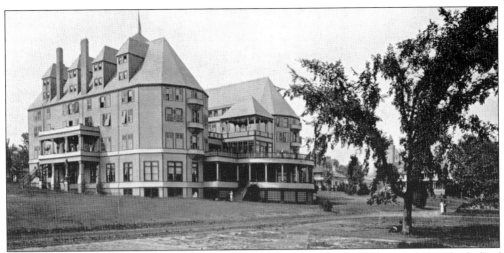

Lakewood's fashionable Kent House, with more than 330 feet of lake frontage, was the hub of the lake's social scene for several years. The original hotel opened in 1875 on the present site of the Chautauqua Lake Yacht Club, near New York Avenue. The second Kent House opened on the same spot in 1888, replacing the first, which had been destroyed by fire. Among the famous guests who enjoyed the fine ballroom and dining room were Theodore Roosevelt, during his 1898 campaign for New York governor; Grover Cleveland, following his presidency; and English author Rudyard Kipling, who had been frustrated by the rigid rules regarding smoking and drinking that he had encountered while at the nearby Chautauqua Institution. (Courtesy Sherry Johnson.)

In operation for 30 years, the rambling Victorian hotel advertised several unique amenities, in addition to its fire extinguishers. The salient features of the New Kent House and Cottage were listed as follows: "Finest Summer Resort in America—Gas and Electric Lights—Electric Return Call Buttons—Elevator from Dining Room Floor to all Floors—Superb Orchestra—Absolutely Pure Water from the Kent House Famous Flowing Artesian Well—Mosquitos Unknown." (Courtesy Jane Currie.)

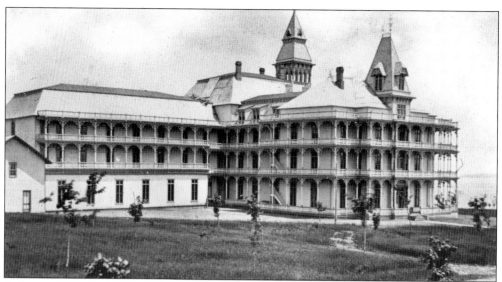

Built in 1870, the Lakeview House was demolished and replaced by the more modern Sterlingworth Hotel and Cottages in 1889. Located near the steamboat pier in Lakewood, the complex was annexed to the Kent House in 1896 and used for the latter's overflow. Located at today's Harley Park site, the Kent House, with its castlelike towers, aimed to attract the most refined and fashionable clientele by advertising its "elite orchestra," "finest summer ballroom in America," "superior service," and Turkish baths. Among its coveted guests was Ethel Barrymore. (Courtesy Kathleen Crocker.)

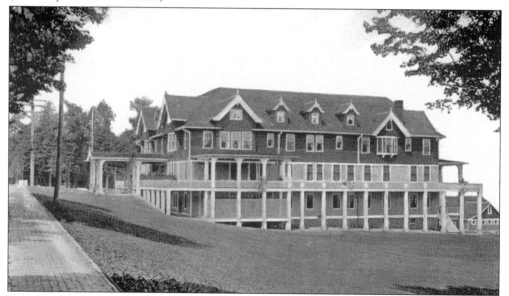

Following the destruction of the Waldmere Hotel, the Lakewood Country Club was built at the foot of Chautauqua Avenue on the site of a portion of the Kent House. Dancing, card playing, boating, and auto rides into the nearby countryside and along the lakeshore were favorite activities. When replaced by the Lakewood Inn, additional recreation was offered. Tennis matches, novelty dancing parties, swimming instruction for the inn's guests, and private lessons in tennis, canoeing, and bowling were all well advertised for the active vacationer. (Courtesy Marjorie Stiles Lamprecht, Vintage Views.)

Five

PARKS AND CAMPSITES

Family outings were a source of anticipation at the end of a long workweek. Regardless of the particular destination around Chautauqua Lake, recreational activities were extensive. Most of the lakeside parks offered picnic groves, baseball diamonds, fishing docks, bathing beaches, band concerts, and spectacular sunsets—all at no cost.

Purchased in 1809 by the Holland Land Company, Long Point was one of the earliest picnic sites. Located on the strip of land jutting into Chautauqua Lake between Bemus Point and Maple Springs, its popularity waned after the advent of the amusement parks developed by the transportation companies.

Celoron, the region's Coney Island, was a prime example of a trolley park. To improve weekend business, rail companies throughout the United States located these parks at the end of their lines on the outskirts of towns. In 1894, the Jamestown Street Railway leased the waterfront at Celoron on the southwestern shore of Chautauqua Lake, just outside the Jamestown city limits. Built by Almet N. Broadhead, the park was named in honor of Pierre Joseph Celoron de Blainville, the French explorer who supposedly camped there while en route to assist the French government claim lands west of the Allegheny Mountains.

Four years later, in 1898, the Jamestown and Lake Erie Railway leased 17 acres of land on the upper end of the lake, and Midway Park became Celoron's competitor. Located directly across from the Chautauqua Institution grounds, Midway, as its name implies, was readily accessible from Jamestown, Mayville, and Bemus Point—all points of transfer on the steamboat lines. Another Broadhead enterprise, the Chautauqua Lake Navigation Company, built a 450-foot steamboat pier at Midway in 1907, negating Long Point's importance as a picnicker's paradise. This pier helped ensure the success of Midway Park, and when the Jamestown, Westfield and Northwestern Railway began to service Midway, 27 more acres were added. The Chautauqua Traction Company also developed Sylvan Park. Located on the west side of the lake between Stow and Mayville, it remained a picnic site until 1926.

As a passenger on the first run of the traction between Jamestown and the Chautauqua Assembly in 1904, Chautauqua cofounder John Heyl Vincent praised the Broadheads for providing "Jamestown residents with the opportunity to take, at a reasonable rate, a trip almost anywhere in the city, to Falconer, to Lakewood, or to villages along either side of the lake and to Westfield."

With the advent of the automobile, families had more options; they could spend vacations beyond the region and motor to new vistas. As a result, the facilities at Celoron were torn down after 50 years, Long Point was turned into a private estate, and Sylvan was transformed into a camp for youngsters; only Midway Amusement Park survived intact. Most local residents recall or have heard tales of these parks and the pleasures they provided earlier generations; photographs and memories must now tell their stories.

Another trend began. More and more individuals and families who journeyed to the Chautauqua Lake region preferred to stay in rustic surroundings rather than be confined in hotels, boardinghouses, and cottages. They chose to spend their time outdoors at established camps along the lake's shore. In fact, much waterfront property became permanent campsites for Bible students, members of the Girl and Boy Scouts of America, and young people involved in YMCA- and YWCA-supervised summer programs.

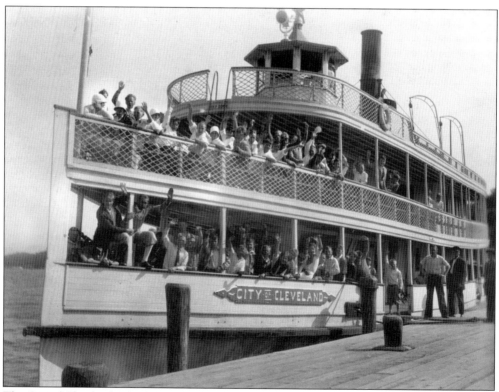

The *City of Cleveland*, which operated on the lake from 1891 until 1925, was used primarily for ferry and charter service on the upper lake. Onyahsa campers and their counselors fill the decks on one of their outings. (Courtesy YMCA, Camp Onyahsa, Jamestown, N.Y.)

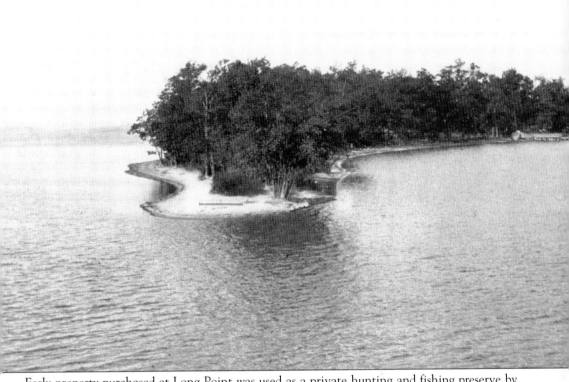

Early property purchased at Long Point was used as a private hunting and fishing preserve by R.C. Johnson of Westfield. The point's natural beauty was its main attraction; it was replete with diving ducks, mergansers, loons, chipmunks, and red squirrels, in addition to magnificent oak, beech, hemlock, hickory, maple, and locust trees. Long Point was the lake's premier picnic grounds in the 1870s and 1880s. Visitors also enjoyed Long Point's bandstand, bathhouse, dance hall, and boat livery. In 1887, the owners of the Allen Opera House in Jamestown developed the property into an amusement park and zoo, which was stocked with at least one elephant, tiger, lion, leopard, kangaroo, anteater, alligator, snake, elk, and moose and a variety of exotic birds. In 1893, the Chautauqua Steamboat Company leased the land and greatly improved the lakeside stop. Jamestown banker Frank E. Gifford purchased the estate for his summer residence. He commuted daily between Long Point and the boat landing on his custom-made launch the *Onosee*, which was deliberately sunk after his death in 1934. The estate was deeded to the state of New York for use as a recreational park after the death of Gifford's daughter Cecile Gifford Minturn, granddaughter of New York Gov. Reuben E. Fenton. Today, Long Point State Park is more active than ever as a favorite Chautauqua Lake region picnic area, bathing beach, and boat launch. (Courtesy Sherry Johnson.)

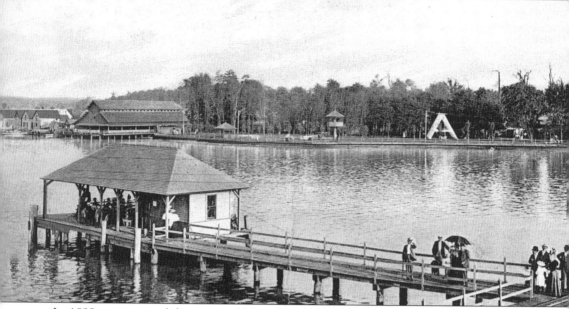

In 1898, executors of the estate of Mary Prendergast sold the 69-acre Prendergast property, located about two miles from Jamestown on the west side of the lake. The swampland was converted into a lakeside resort, and its name was changed from Prendergast Point (now the name of a private community near the Chautauqua Institution) to Celoron. When owned by the Broadhead family, this distinctively long dock was built to accommodate steamboats but was also used by the Greenhurst–Celoron ferry, individual launches that shuttled visitors between the park and the Lakewood hotel docks and across the lower lake, and the trolley line, above,

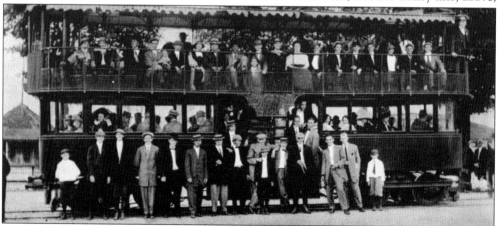

Most visitors to Celoron Park arrived from the Jamestown boat landing on this double-decker trolley, the most profitable venture of the Jamestown Street Railway Company. Named the *Columbia*, to honor the Columbia Exposition in Chicago, it operated for about 20 years, beginning in 1893. Day and night, it could shuttle up to 50 passengers, plus hangers-on, far faster than the steamer could make its run through the outlet to the park. Manufactured by the Pullman Coach Company, the car boasted a smoker, seats for the ladies, and outward-facing upper-deck benches. George M. Pullman, who designed comfortable sleeping cars, the first of which were used in Pres. Abraham Lincoln's funeral train procession, was a native of Brocton in Chautauqua County. (Courtesy Marjorie Stiles Lamprecht, Vintage Views.)

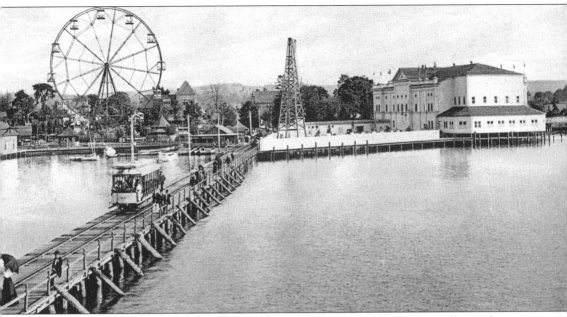

which branched off the park loop to meet arriving passengers at dockside. Harry Illion, whose family designed and built amusement park rides, bought Celoron Park from the estate of Almet N. Broadhead only to close it in the 1960s. He purchased another park in California, where he relocated the Circle Swing, Phoenix Wheel, and the large carousel. Celoron's buildings were torn down, and Lucille Ball's once bustling hometown settled into a quiet lakeside community. (Courtesy Sydney S. Baker)

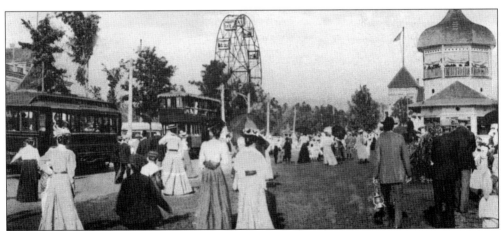

Large crowds were the norm at Celoron Park, but on July 4, 1897, a staggering 25,000 visitors were reported to have been on the grounds. Overnight guests and daily visitors had a wealth of options. The Phoenix Wheel, in the center, was brought from the Cotton States Expo in Atlanta, Georgia, to Celoron in 1896. From the 12 wire cages, peaking at 115 feet above the lake, riders had a fabulous view of the lake, as well as of the park's Greyhound roller coaster, carousel, toboggan waterslide, illuminated electric fountain, Circle Swing, and other attractions. Opened c. 1912, the park's zoo boasted bears, wildcats, monkeys, peacocks, deer, and antelope. Visitors could cap their day at the open-air band shell or theater or with a promenade throughout the grounds, savoring their experience. (Courtesy Marjorie Stiles Lamprecht, Vintage Views.)

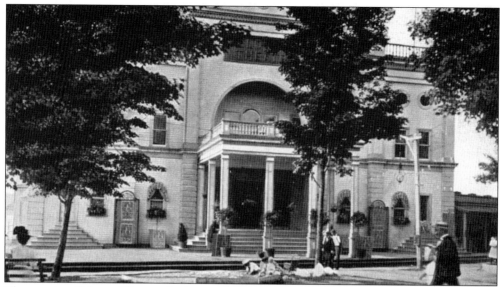

The massive Celoron Theater, built on pilings out over the lake, drew crowds of up to 2,000 until it burned in 1930. Famous road shows, opera companies, summer stock companies, top vaudeville attractions, comedians, acrobats, magicians, and even novelty bicyclists appeared on its stage and were well publicized for local audiences. The *City of Cincinnati* made nightly runs between Lakewood, the Chautauqua Institution, and Mayville to accommodate its patrons. (Courtesy Kathleen Crocker.)

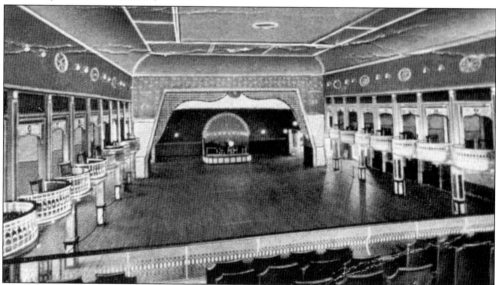

The ornate Celoron Amusement Park Theater was converted into the nationally known Pier Ballroom and drew large audiences until after World War II. Bandleader Stu Snyder, who spent 25 years affiliated with the dance hall, once commented that "a band didn't really count unless it played at the Pier." Among the famous musicians who performed on its stage during the 1930s and 1940s were Cab Calloway, Earl Hines, Louis Armstrong, Les Brown, Ella Fitzgerald, Sammy Kay, Tommy Dorsey, Guy Lombardo, and Frank Sinatra. Patrons were devastated when it burned to the ground in 1930, as did its replacement in 1961; magical evenings at the Pier ceased forever. (Courtesy Kathleen Crocker.)

Only a minute portion of the popular Circle Swing, located down in the grove about 150 feet from the Celoron dance pavilion, can be seen in this photograph. Decked out in his uniform, Martin Furlow, left, operated the venture in the early 1900s. He is pictured with his wife, Belle, and their daughters Lillian and Laura Furlow. (Courtesy the Ernest and Helen Smith family.)

Most popular bands of the era played at both the Casino in Bemus Point and at the Pier Ballroom in Celoron, mesmerizing enthusiastic audiences, as did Guy Lombardo in the fall of 1961. (Courtesy Sydney S. Baker.)

The stylish women on the right, who conjure up memories of characters from the movie *Some Like It Hot*, pose on the Celoron Pier during their day's outing. How casual wear has changed! (Courtesy Jean W. Loehr.)

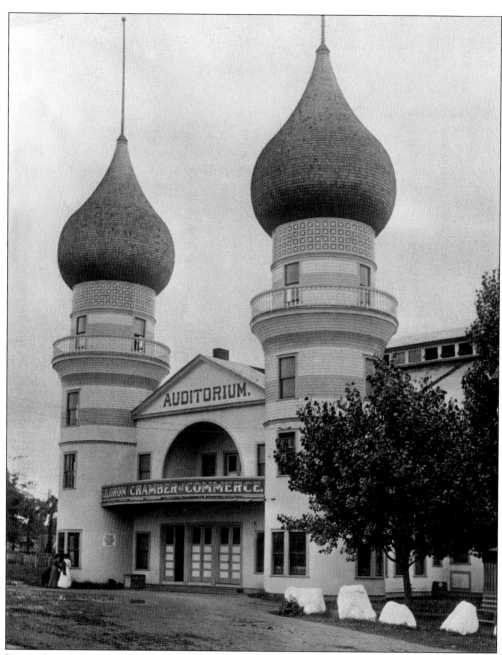

Located to the south of the main entrance, the impressive oriental-style auditorium, with its two Moorish, onion-shaped domes, was "the pride of the sleepy lakeside town of Celoron," according to newspaper staff member Paul Davis. In 1896, its 6,000-seat capacity was taxed when William Jennings Bryan chose it as the site for a political rally during his 25-state whirlwind campaign for the presidency; since his wife had previously visited the Chautauqua area, she encouraged her husband to do the same. Prior to being destroyed by fire in 1920, the "Aud" hosted the first Jamestown furniture exhibition. During the summer it was a dance hall and then was converted into an ice-skating rink for the winter months, providing year-round entertainment for park patrons. (Courtesy the *Post-Journal*, Jamestown, N.Y.)

Celoron native Lucille Ball (1911–1989), internationally acclaimed television comedienne of *I Love Lucy* fame, retained lifelong ties to the Chautauqua Lake region. Frequent references were made to hometown friends and places in her productions, and several of her childhood friendships endured throughout her lifetime. Her California home contained furniture manufactured in Jamestown, and she occasionally indulged herself by ordering Swedish limpa bread from a local bakery to be delivered out west. Long before her Big Apple exposure, she attended vaudeville shows at Jamestown's Palace Theater. Her acting career probably began at a Celoron Parent-Teacher Association talent show, which was followed by performances in Jamestown at the Players' Club (now Little Theater) and at the Chautauqua Institution in 1930. In 1946, during a three-day visit back home, she took the helm of the *City of Jamestown* steamer, which was transformed into a showboat for her homecoming. As guest of honor, she and her entourage steamed up the lake to attend a minstrel show at Smith Wilkes Hall at the Chautauqua Institution and, on the return trip, made a lengthy stop at Midway's rink, where she roller-skated as she had done as a young girl. To the community's delight, she chose Jamestown as the site for the world premiere of *Forever Darling*, which she attended with her husband, Desi Arnaz. In spite of her celebrity status, she generously recognized her roots by donations to the local Women's Christian Association (WCA) Hospital. Prior to her sudden death, she was making preparations for a return trip to Jamestown to attend the first annual Lucy Fest and to receive an honorary degree from Jamestown Community College. The city's Lucy-Desi Museum, filled with memorabilia, yearly attracts thousands of her fans, who travel from all over the United States and abroad to glimpse a bit of lighthearted Americana that so endeared her to audiences worldwide. (Courtesy the *Post-Journal*, Jamestown, N.Y.)

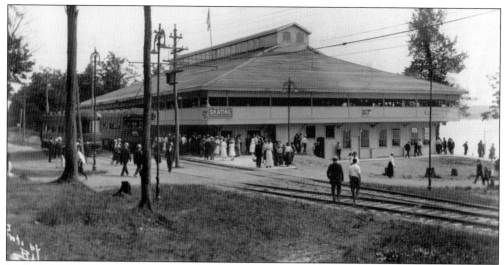

Midway Park is the 15th oldest continuously operating amusement park in the United States; Seabreeze in Rochester is the only other in New York State. This 1920 photograph provides a wonderful view of not only the skating rink and bathhouse pavilion but also the Jamestown, Westfield and Northwestern tracks, which brought patrons to the lakeside park. Although it never attracted the big name bands that played the Casino and the Pier Ballroom, Midway Park hosted several noted musicians upstairs in its ballroom. In addition to the orchestras of Glenn Miller, Stan Kenton, and Les Elgart, late-night television host Jack Parr visited Midway Park while staying with friends across the lake at Prendergast Point. (Courtesy Mary Jane Stahley.)

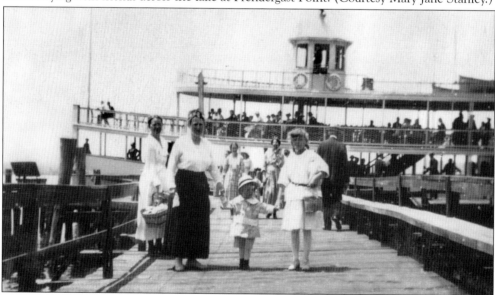

Midway picnickers arrived by the boatload on a regular basis, either as family units or as part of an organization's excursion. An unusual event of July 1901 was the Jamestown Merchants Picnic. Nearly 2,000 druggists, jewelers, furniture dealers, bakers, cigar dealers, and various other city shopkeepers closed their doors before noon, met at the boat landing with their families, and boarded chartered steamers bound for the Midway picnic grounds. Prior to their return sunset cruise, they participated in activities that included bathing, boating, baseball, tennis, and amusement rides. (Courtesy the Cornelius Fisher family.)

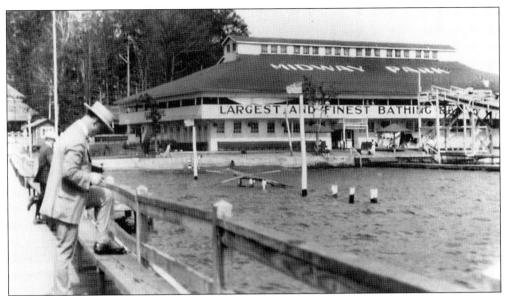

Since being built in 1915 by the Chautauqua Lake Navigation Company, the large open-air lakeside pavilion at Midway has welcomed thousands of visitors and remains a landmark on the lake. The first floor has housed dressing rooms, a dining room, concessions, and a shooting gallery; both roller-skating and dancing were held upstairs. This picture was taken c. 1928, and little has changed except that the steamboat dock on which this photographer stood is long gone. (Courtesy the Walsh family.)

Midway Park celebrated its 100th anniversary in 1998 and, unlike most businesses, the 1,200-foot lakefront facility has remained admission free for those who choose to picnic, swim, watch annual Fourth of July fireworks displays, or stroll through the arcade. Although its unforgettable fortune-teller Princess Doraldina now resides in the park's museum and the Jack Rabbit roller coaster and toboggan waterslide are mere memories, today's visitors may relish the Tilt-a-Whirl, bumper cars, go-cart track, miniature golf course, arcade, carousel, and the ever-popular skating rink. (Courtesy the *Post-Journal*, Jamestown, N.Y.)

This 1940s poster advertised roller-skating at Midway Park, which began in 1915. In order to provide year-round skating, when the park's summer season ended, Martin "Red" Walsh operated the Washington Street Rollarena in Jamestown, not far from the grand scale ice-skating arena currently under construction. (Courtesy the Walsh family.)

Roller-skating and Midway are synonymous. Local residents fondly remember the center rink and outside track on the second floor of the pavilion; they can probably hear the Hammond Organ music, as well. Countless couples, like Morgan and Shirley Thayer, shown in 1949, courted there, and their pictures are displayed on the Sweetheart Board in the park's unique museum. (Courtesy the Walsh family.)

84

In this 1969 family photograph, owner Red Walsh is shown beside one of his beloved jumping aluminum horses, manufactured by the world-renowned Allan Herschell Carousel Company of North Tonawanda, near Buffalo. The colorful carousel horses, accompanied by distinctive calliope sounds, are still located in the park's open-air roundhouse. A pioneer in the amusement park business, Walsh purchased Midway in 1951 from the estate of Thomas Carr, the former manager of Celoron Park. The park's longevity is attributed in great part to the able management and ownership of Walsh and his brother Frank Walsh and, since 1984, that of his son Michael Walsh and daughter-in-law Janis, who take enormous pride in the family's enterprise and continue to emphasize wholesome family and educational values in the very best of settings. (Courtesy the Walsh family.)

Several private clubs and organizations have also taken advantage of Chautauqua Lake's attributes for their group's summertime activities. In 1945, the Ingjald Lodge, Independent Order of Vikings, bought nearly 2,000 feet of lakeside property adjacent to Midway Park. The picturesque Viking Lake Park, with its private dining facilities, lounge, bathing beach, playground, picnic grove, boat launch, and campsite, has been enjoyed by generations of its Scandinavian American members. Ten years earlier, a group of ardent sportsmen formed the Lakewood Rod and Gun Club and, on the lower lake near Celoron, built a clubhouse, where the large membership gathers year-round to dine and participate in a variety of special events. (Courtesy Sydney S. Baker.)

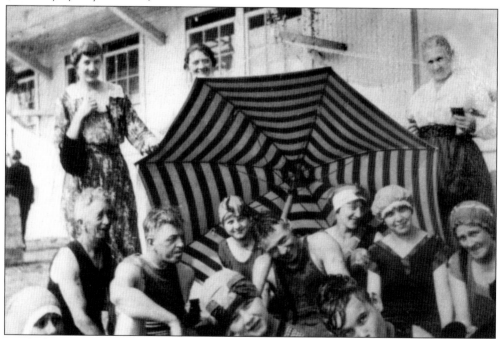

No doubt these sunbathers not only enjoyed sitting under umbrellas but also took advantage of the clear water along Midway's sandy beach and the park's rafts, diving platform, and water toboggan slide. The balance of their day might have been spent on the roller rink or dance floor before returning home. (Courtesy Mary Jane Stahley.)

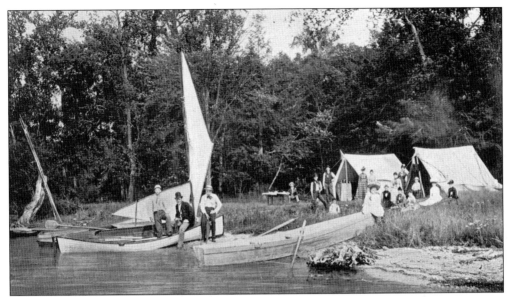

For these family members, despite their austere appearance and cumbersome attire, camping and picnicking were probably rare treats a century ago. Like them, generations of campers and park visitors have spent leisure with families, companies, church and school groups, or fraternal organizations at choice picnic groves around Chautauqua Lake. (Courtesy Sherry Johnson.)

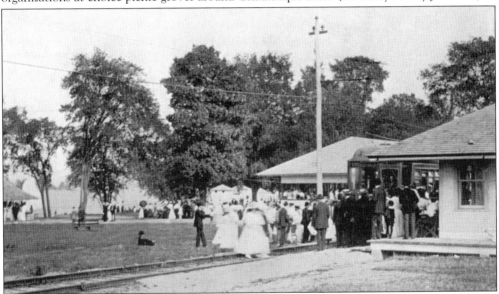

The site of an Indian encampment in the early 1800s, Sylvan Park, located on the west side of the lake near the Chautauqua Institution, was developed by the Chautauqua Traction Company in 1907. Its picnic grove, large dance hall, and bathhouses were enjoyed until trolley service was suspended in 1926. The park was then sold and became Camp Twa Ne Kotah for girls, which operated for over 30 years. Considered a cultural camp, the girls participated in golf, hiking, dramatics, riding, dancing, athletics, and water sports. The popular Chautauqua Campgrounds, rated among the top 100 camping resorts in the United States, currently owns and operates the facility, one of the most splendid pieces of property on the lake. (Courtesy Kathleen Crocker.)

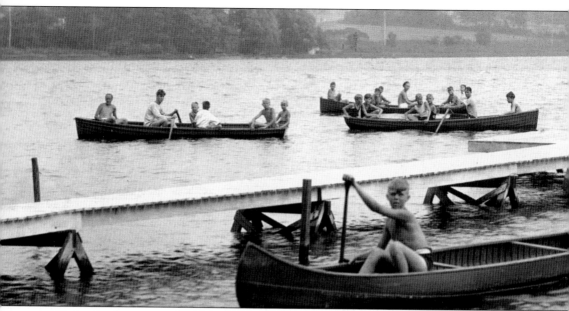

Both the Jamestown YMCA and YWCA have sponsored lakeside camps. Special daily programs for 35 to 40 girls were held by the YWCA Girl Reserves at a permanent camp converted from a private residence at Shady Side near Lakewood. In 1920, Camp Prendergast sponsored a full slate of activities under the leadership of the local YMCA. Those campers explored the caves and crevices of Panama Rocks and also attended Sunday morning worship services at the neighboring Chautauqua Institution Amphitheater. About the same time, the

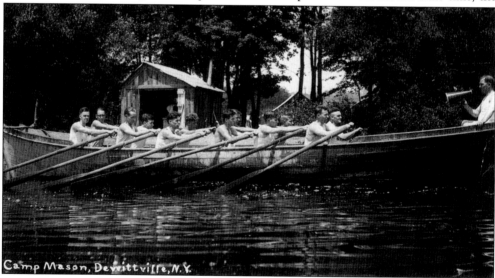

This 1924 postcard depicts oarsmen from the YMCA camp formerly known as Camp Mason. The camp's name was changed to Camp Onyahsa, an Indian name, and moved from Tom's Point across the lake to Dewittville in 1939. Leaders from the Jamestown YMCA intended to provide boys an escape from city life to the beauty of nature's outdoors. Originally for boys only, the camp expanded to include their families and girls, but its mission has remained the same: "the development of spirit, mind, body and community." (Courtesy YMCA, Camp Onyahsa, Jamestown, N.Y.)

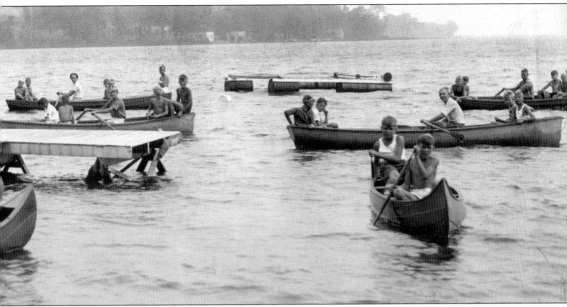

YMCA sponsored a county-wide boys' camp at Belleview, a stop on the Jamestown, Westfield and Northwestern railway south of Bemus Point, so that city boys and those from rural districts could camp lakeside. Ministers and teachers of Sunday school classes for boys were invited to accompany the youngsters on sailing trips, at baseball games, and at track events. Special events included bicycle rides to Midway Park and the creation of minstrel show productions. (Courtesy YMCA, Camp Onyahsa, Jamestown, N.Y.)

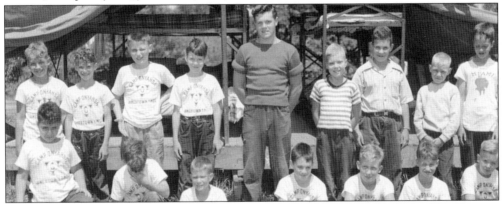

Founded in 1898, Camp Onyahsa has the distinction of being one of the three oldest Y camps in the United States. Under the able directorship of Roy Wagner (1924–1946) and Spiro Bello (1962–1982), it attained capacity enrollment, emphasizing boating, water safety, sports, hiking, and nature. Counselors from different countries, including Ireland, Canada, Spain, and Scandinavia, introduced the campers to a variety of cultures. Regarding the educational benefits of securing both local and foreign staff members, the camp's current director, Jon O'Brian, who began his own career at Onyahsa as a camper in 1971, explained that this international flavor "helps broaden the outlook" of campers. This 1956 photograph of campers and their counselor was taken in front of one of the many platform sleeping tents. Several years later, former camper Michael K. Lyons recalled that for his friends and him, Camp Onyahsa meant "freedom, escape, release, controlled mayhem . . . a perfect place to be." (Courtesy YMCA, Camp Onyahsa, Jamestown, N.Y.)

Girls also had the chance to spend summer days with their groups on Chautauqua Lake. Under the auspices of the Chautauqua County YWCA, Chedwel—the summer estate of Charles Edgar Welch, president of the Welch Grape Juice Company in Westfield—opened in 1912 to girls from 12 to 14 years old. Not surprisingly, Welch, a devout Christian with strong ties to the Methodist Assembly at the Chautauqua Institution across the lake, ensured that religion be integral to the camp's program. Beginning with Bible study, each day's schedule included instruction in swimming, tennis, and basketry. In 1923, the Chautauqua Area Girl Scout Council borrowed a former Boy Scout campsite for its one-week camp and four years later leased property near Midway Park. The Girl Scout Camp Newatah was purchased in 1928 and was attended in the 1950s by one of the authors. Boy Scouts, too, had access to lakefront camping. In 1933, Frank Merz generously donated to them a 366-acre tract at Lighthouse Point near Mayville. The Camp Merz property was deeded to the National Boy Scout Council as perpetual trustee for the use of Chautauqua County boys. (Courtesy the *Post-Journal*, Jamestown, N.Y.)

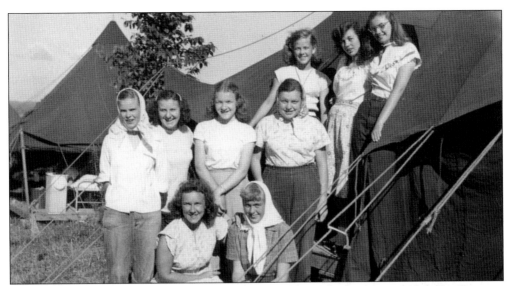

Bible and church camps have dotted the lake since the Methodists convened at Fair Point in 1874. Religious services and meetings were usually held outdoors in sacred groves. Pictured in front of their tent in 1947 are girls at Camp Mission Meadows, a modern version of those early religion-based campgrounds. The previous year "Nine Old Men," a reference to the U.S. Supreme Court during Harry Truman's presidency, were charged with founding a permanent campsite for the covenant churches of western New York. They were fortunate to find an advertisement in the *Pittsburgh Press* for 26 acres of gently sloping meadow on the northeastern shore of Chautauqua Lake. Ever since those men supervised the camp's organization, girls and boys have benefited from their wise choice. (Courtesy Camp Mission Meadows.)

The Lake Chautauqua Lutheran Camp, formerly called Camp Elba, began operation in the 1930s and was first located at the site of Camp Newatah. Eventually, the Lutheran Bible Camp Association purchased property with nearly 700 feet of lake frontage, easily accessible via the Jamestown, Westfield and Northwestern trolley line. Its buildings and supervised programs grew steadily, and campers like this young boy are drawn each summer to this delightful spot on the lake. (Courtesy Camp Chautauqua Lutheran Center.)

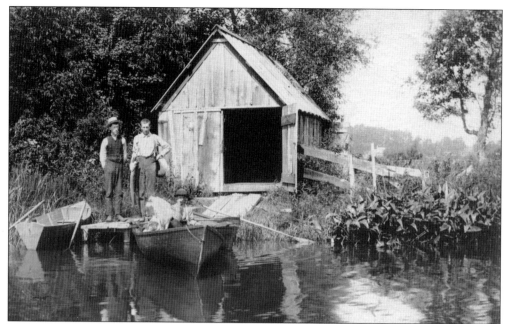

This rustic scene is reminiscent of Tom Sawyer and Huck Finn, only set in the Chautauqua Lake region rather than along the Mississippi Rover. If not on a summer outing, the trio, like Samuel Clemens's characters, might just have played hooky in order to relish a day's fishing on their own. (Courtesy Jane Currie.)

Many families returned yearly to their favorite campgrounds or cabins on the lake, renewing friendships with their summer neighbors in tranquil settings. Fathers and sons, like these two, could take time to strengthen bonds and create lifelong memories of idle days spent at Chautauqua Lake. In the mid-1900s, private and affordable tourist cabins were popular accommodations for vacationers. Eugene French, owner of French's cabins at Shore Acres near Bemus Point, ingeniously converted an old Jamestown, Westfield and Northwestern trolley car into a motellike unit. (Courtesy the *Post-Journal*, Jamestown, N.Y.)

Six

INDUSTRIES AND
OCCUPATIONS

In 1853, Jamestown native Reuben E. Fenton, governor of New York during Pres. Abraham Lincoln's administration, made these remarks to the Chautauqua County Agricultural Society: "Chautauqua cattle, Chautauqua horses, Chautauqua manufacturers, Chautauqua butter and cheese are known and appreciated almost through the length and breadth of our land." In 1926, speaking at the dedication of the Third Street Bridge in Jamestown, Chautauqua Institution Pres. Arthur E. Bestor made reference to the connection between the Chautauqua Institution and Chautauqua Lake: "If we have something really worthwhile, and we have; if Chautauqua Lake is the ideal resort for influential Americans, and it is; if we have the beauty of scenery, the natural advantages, the opportunities for delightful community life, the educational prestige not to be excelled by any other resort in American, and who will deny it? Then we ought to make Chautauqua Lake the best known resort on the continent."

These similarly powerful testaments to the region's many industries, including that of tourism, made nearly 75 years apart, emanated from dynamic leaders who both spent many years living in the area themselves and were knowledgeable about the region's natural attributes and the nature of its hard-working citizens.

The natural advantages referred to by Bestor resulted in a progressive manufacturing entity with a diversification of industries. More than 400 area manufacturing concerns once produced 60 or more different products that were shipped throughout the country and abroad: pianos, ball bearings, brooms, washing machines, metal office furniture, ad infinitum. Grape and ice harvesting, diversified farming, and the lumber industry with its offshoots also provided a steady income for county residents.

According to city historian B. Dolores Thompson, by 1900 Jamestown had become the undisputed industrial center of the county, and its four major industries were wood furniture, worsted fabric, light metal products, and photographic paper. Its worsted woolen mills were among the first established in the United States, and its textiles were unsurpassed.

In addition to factory work, however, many county residents chose occupations of a far different sort. The tourism industry alone provided employment opportunities for steamboat pilots, railroad conductors, bellhops, hotel chefs, nannies, and baggage handlers—just to name a few. Individual entrepreneurs, an unknown term in those days, existed in every village and certainly served as role models for their children and community members.

This bill was submitted in 1897 on Hopson and Carlson Ice House stationery to W.D. Parker, the town clerk of surrogate court. Owners Ben Hopson and Gus Carlson operated their facility near the Mayville depot from 1888 until its roof collapsed in 1927. (Courtesy Sydney S. Baker.)

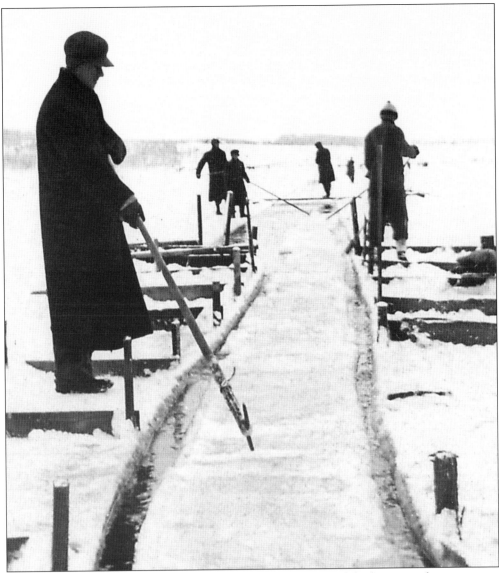

The ice-harvesting industry around Chautauqua Lake was one of the largest ice businesses in the United States *c.* 1900, its season lasting anywhere from four to ten weeks depending upon a number of varying factors. Although the younger generation has no concept of a world without refrigerators and freezers, the numerous icehouse companies were crucial to some businesses and to all the lake hotels that bought the ice to store on their own premises. The two oldest companies, Chautauqua Lake Ice and Pittsburgh Ice, were established *c.* 1870 near the Mayville depot. Other companies in the upper lake region included Cornell and Hewes, Hopson and Carlson, Fisher and Wooglin; icehouses at Lakewood, Celoron, Bemus Point, and Clifton serviced the lower lake region. Ice was first used commercially with the advent of railroads in 1871, which made its transport available and affordable. Spring-fed Chautauqua Lake's pure, high-quality ice was cut from the lake, insulated with both straw and sawdust, stored during the winter months, and then shipped out by rail in the summertime. Ice-filled boxcars transported the precious commodity to cities, such as Buffalo and Pittsburgh, that lacked their own pure, natural ice. (Courtesy Devon Taylor.)

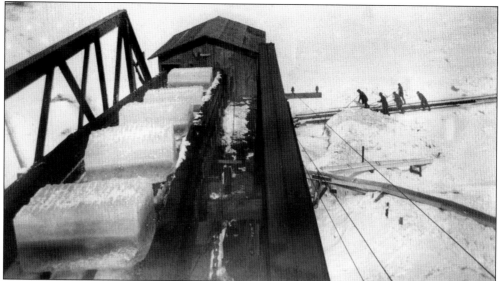

Each ice block measured approximately 12 to 18 inches in thickness and 22 by 30 feet in size. Workers used pikes and poles to float the blocks to the icehouse door and up an incline via conveyor belt to openings at various levels in the icehouse. The blocks were painstakingly stacked into several layers in the storage rooms. Great care was taken to set them far enough apart to avoid their freezing together and to provide sufficient insulation on the top layer to protect all of the blocks below. (Courtesy Jane Currie.)

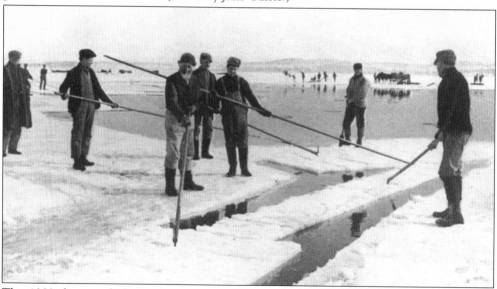

This 1900 photograph depicts ice cutters on Chautauqua Lake. The ice-harvesting process was rather basic but physically grueling. Aided initially by horses and later by gas power, workers scraped the snow from the ice surface, marked the ice, sawed it into blocks, opened a channel, floated the massive blocks to the icehouse, and maneuvered them inside in preparation for winter storage. Permanent icehouse employees were joined in their hours of backbreaking tasks by seasonal help from nearby towns and villages and even by transient laborers from Buffalo and Pittsburgh. This, of course, aided the local economy because a number of private homes around the lake were needed to board the out-of-towners. (Courtesy Mary Jane Stahley.)

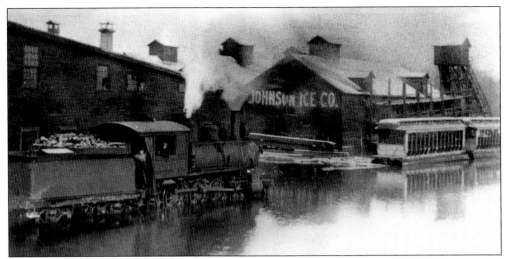

The icehouses on Chautauqua Lake were located adjacent to the railroad or a siding near either Mayville or Jamestown in order to have easy access to rail transportation. Danish American brothers Charles and John W. Johnson established their first icehouse in 1897. Named the Clifton Ice House, it was located on the east bank of the Chadakoin near the outlet and Jamestown steamboat landing. In 1881, they partnered with two Swedish brothers, also named Johnson, Oscar F. and Charles A., to operate the Jamestown Ice Company. The company harvested about 15,000 tons of ice yearly, storing it in warehouses on the lower lake. It ceased operation c. 1920, when the ice business began to be outmoded. (Courtesy Patterson Library, Westfield, N.Y.)

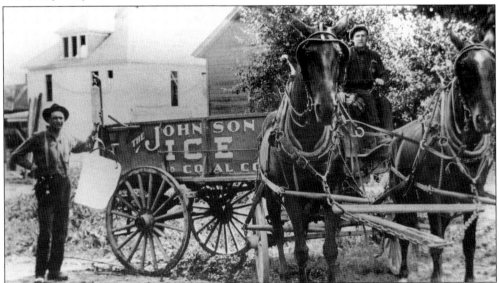

The two Johnson Ice and Coal Company deliverymen and their horses posed for this rare photograph. Note the ice block hanging between tongs near the rear of the wagon. Deliveries to homes and to independent grocers, meat markets, and creameries were welcomed summertime events. Signs displayed in windows indicated the amount of ice desired, and children eagerly begged for ice chips to quench their thirst. Even when trucks replaced the horse-drawn wagons, these companies provided summer employment, especially for college students. (Courtesy Sydney S. Baker.)

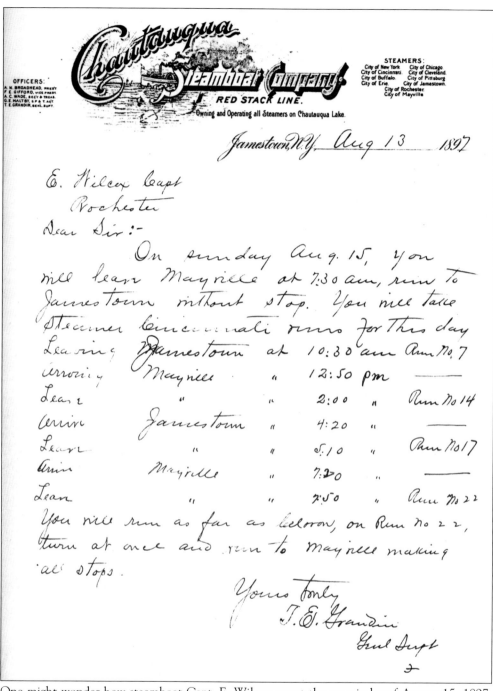

Chautauqua Steamboat Company
RED STACK LINE.
Owning and Operating all Steamers on Chautauqua Lake.

STEAMERS:
City of New York City of Chicago
City of Cincinnati City of Cleveland
City of Buffalo City of Pittsburg
City of Erie City of Jamestown
 City of Rochester
 City of Mayville

Jamestown, N.Y, Aug 13 1897

E. Wilcox Capt
 Rochester
Dear Sir:—

 On sunday Aug. 15, you
will leave Mayville at 7.30 am, run to
Jamestown without stop. You will take
Steamer Cincinnati runs for This day
Leaving Jamestown at 10:30 am Run No 7
arriving Mayville " 12:50 pm ————
Leave " " 2:00 " Run No 14
arrive Jamestown " 4:20 " ————
Leave " " 5:10 " Run No 17
Arrive Mayville " 7:30 " ————
Leave " " 7:50 " Run No 22
You will run as far as Leloron, on Run No 22,
turn at once and run to Mayville making
all stops.

 Yours truly
 T. E. Grandin
 Gen'l Supt

One might wonder how steamboat Capt. E. Wilcox spent the remainder of August 15, 1897. (Courtesy Sydney S. Baker.)

Over the years, hundreds of area residents were employed by the Chautauqua Lake Steamboat Company. Pilots, under the supervision of captains, were responsible for the manual steering of the large vessels that plied the lake. More than one individual was needed to maneuver the *City of Cleveland* and others of similar size through the meandering outlet. Pilots were stationed mainly in octagon-shaped pilothouses, with windows on seven of the sides and a door at the rear. Most pilothouses were also capped by a searchlight and a decorative eagle. (Courtesy Sydney S. Baker.)

This scene is one for conjecture. Certainly, the steamers needed service prior to major overhauls and repairs at the Clifton shipyard, located midway up the outlet. Steamers were often towed to dry dock, where large cranes hauled them out of the water sideways so that hulls could be repaired. This diver might have been involved in any number of tasks. He could have been checking basic equipment or dealing with engine or boiler problems or, when the Great White Fleet began to be abandoned, he might have been one of many divers clamoring for the steamers' remains. (Courtesy Sam Calanni.)

Built by George Griffith in the early 20th century, the Mill was a Dewittville landmark and afforded a decent livelihood for hundreds of Chautauqua County farmers for many years. In addition to being a gristmill, it also housed an apple press, which first produced vinegar and, in the 1930s, quality cider. Fertilizer, coal, cement, and sundry other building supplies were sold there. The Mill discontinued operation in 1958, following the decline of the small farmer and the corresponding growth of large mill cooperatives. (Courtesy Jane Currie.)

Neil Hansen's blacksmith shop, on Maple Street in Bemus Point, and Jim Culver's wagon shop, the site of the present village hall, were typical of the many small businesses that were necessary to farming and community life c. 1900. Almost every village was self-sufficient and produced its own goods, which included carriages, wagons, buggies, saddles, harnesses, barrels, pottery, shoes, clothing, hats, furs, flour, and various staple crops such as corn and wheat. (Courtesy Mary Jane Stahley.)

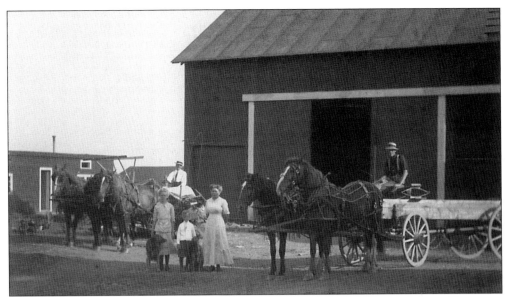

Necessities were provided by one's own family or bartered from neighbors. Numerous children were needed to pitch in alongside parents, grandparents, and other relatives to provide ample sustenance for the household. Both as forms of recreation and practicality, various bees—husking, quilting, logging, and raising bees—accomplished necessary tasks, providing occasions for feasting, storytelling, and general goodwill among community members. (Courtesy David Larson.)

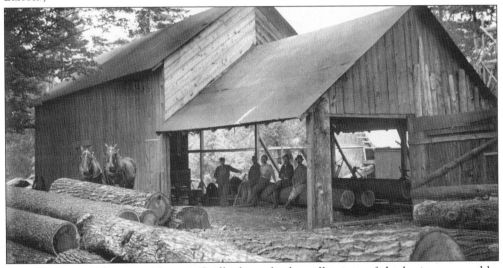

Tom Hopson and his sister Virginia Griffin have fond recollections of the business owned by their father and uncle, which specialized in the importation of draft horses from Iowa to western New York from 1917 to 1946. Good, strong horses were needed in local lumber camps, oil fields, breweries, bakeries, and milk companies and, of course, on farms. According to a recent article in the *Draft Horse Journal*, written by the Griffins, the horses used to plow streets and build roads and were, in essence, "the backbone of the workforce in the early 1900s, the trucks and tractors of their time." The Hopson brothers and children truly cherished their horses and especially fancied the farm horses that hoed their family's Westfield vineyards. (Courtesy Jane Currie.)

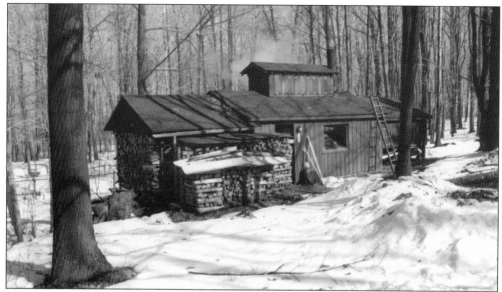

Western New York ranks high in the national production of sugar maple. During the late winter and early spring, maple trees, indigenous to northeastern states, are tapped to release their liquid, which is made into syrup. The process, discovered first by Native Americans and used as a means of barter, involves drilling small holes through the tree's bark, inserting spouts into the holes, and hanging metal buckets to collect the liquid. Many area sugar shacks host tasting parties as a sales promotion. (Courtesy Jane Currie.)

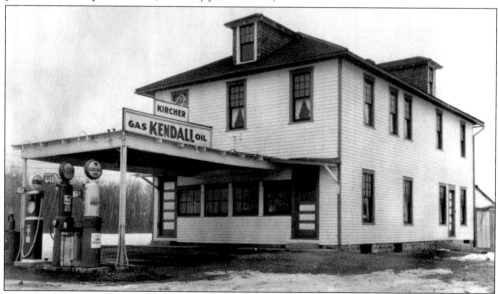

Edward Kircher left the Pittsburgh area to relocate between Bemus Point and Point Chautauqua. In the early 1920s, he built this gas station, complete with living quarters and an attached restaurant and lounge, on the highway overlooking the lake. He also raised dairy cows and chickens. Most area residents remember that the site was purchased by the Davey family and that Davey's Restaurant was renowned for its fabulous fish dinners. This prime piece of property was sold at auction in 2001 due to the retirement of its current owner. (Courtesy the Clarence Kircher family.)

102

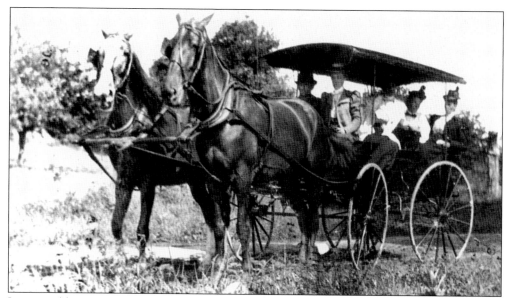

Livery stable owners around the lake were kept busy. Nott's Livery at the Mayville House was known for its first-class horses and buggies. Hopson's Livery Service was often called upon during severe winters to transport lawyers, wrapped in bearskin rugs, up the middle of the lake from Jamestown to the county seat in Mayville. In his rig, above, livery owner Ward Cadwell took his clients on frequent trips to the spiritualist center at Lily Dale and to Panama Rocks. (Courtesy Jane Currie.)

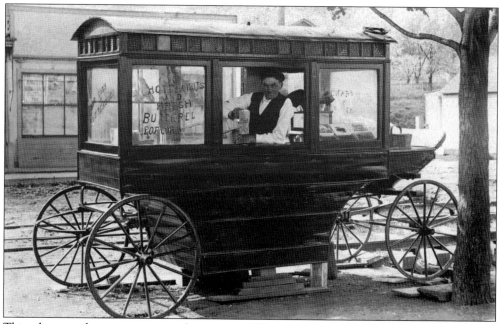

This photograph captures a novel enterprise. This ingenious vehicle, a mobile concession stand, was set up on blocks to maintain its stationary position when located near train depots or steamboat landings to service passengers. "Hot peanuts and fresh buttered popcorn" were advertised on the car's windows, and open boxes of cigars were displayed to the right of the vendor. (Courtesy Devon Taylor.)

Coauthor Kathleen Crocker found both of these vintage Bemus Point photographs in her grandmother's scrapbook. Townsfolk would gather at this Main Street business section to converse and gossip, especially during the seemingly endless winter months. Skillman's has continued its operation on a much larger scale; however, all that remains of the Sullivan and Barrett grocery store and upstairs living quarters, to the right, is a parking lot. Owned and managed by Crocker's paternal grandfather and his brother, the business sold groceries, meats, clothing, flour, tools, hardware, and various sundries. (Courtesy Kathleen Crocker.)

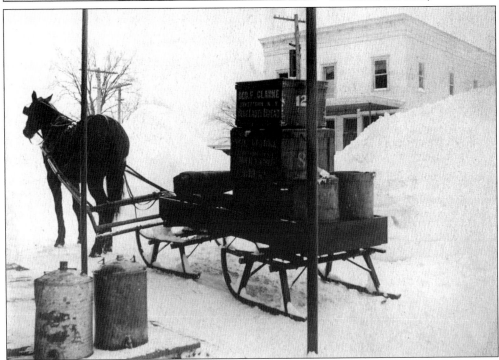

This horse-drawn delivery sleigh waiting patiently in front of the grocery store must have been a familiar sight since "Old Jim" was handwritten above the horse's head on the original photograph. Apparently, the driver of the George F. Clarke Blue Label Bread Company sleigh is inside conducting business with the shop's proprietors. Note the two large crocks at the back of the sleigh and the metal containers on the stoop; their contents can only be imagined. (Courtesy Kathleen Crocker.)

Following in the footsteps of both his paternal and maternal grandfathers, both early cheesemakers in Maple Springs and at Pleasantville near Dewittville, Ford Cadwell, left, operated a 250-acre dairy farm in Dewittville, producing his own cheese from 1927 to 1947. This c. 1940 photograph of Cadwell and hired hand Wayne Murdock shows the men working over a 400-gallon-capacity vat from which they made ten 30-pound wheels of cheese daily. Cadwell's Cheese House, under the management of Cadwell's daughter, Jane Currie, will celebrate its 75th anniversary in 2002. Although the cheese products have been purchased elsewhere since 1947, the retail business continues to be a traditional stop for vacationers, part of the "nostalgia trail." (Courtesy Jane Currie.)

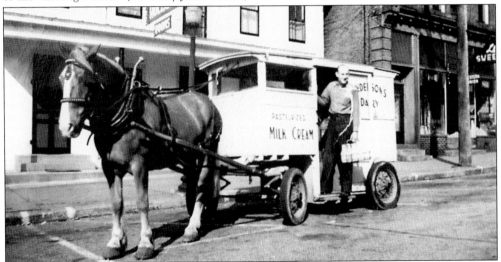

Land and climate conditions in Chautauqua County were conducive to a profitable dairy industry. By 1900, there were approximately 42 cheese factories and 35 creameries in business. Anderson's Dairy, in Mayville, founded by "Sliv" Anderson, provided a delivery service for its customers, as did ice and coal companies in the area. Anderson's horse-drawn delivery wagon is seen in front of the Hotel Holland and Leslie's Sweet Shoppe. (Courtesy the Charles Anderson family.)

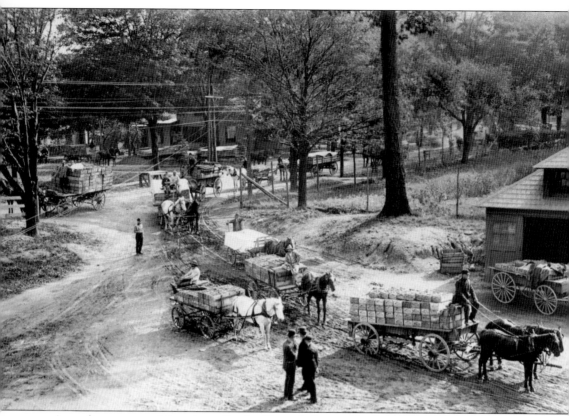

According to an article written for the *Grape Industry*, Charles Edgar Welch, founder of the Welch Grape Juice Company plant in the late 1800s, wrote that a "continuous stream of heavily laden wagons and trucks passes along the [Portage] road. Every where is hustle and bustle during the Chautauqua grape harvest." The county's grape belt vineyards extended along the Portage Road from Mayville to Westfield, the industry's center. Parallel rows of Concord grapes tied to two- or three-foot-high wires were visible for miles. Plowing, cultivation, spraying, and fertilization of the grapes were essential steps prior to the actual harvesting. Handpicked by family members, neighbors, and migrant workers, the grape clusters, once cut at the stem by hand shears prior to carting and crating, were then delivered to the Welch plant, as seen above. Backbreaking picking that once took up to six months became measured by hours and days with the invention of the mechanical harvester. Located near the depot, the Welch plant made shipments worldwide in the form of grape juice, fresh fruit, jellies, and jams. The company's growth was due in part to its vigorous advertising campaigns. Begun in church magazines and newspapers, advertising promoted displays and sales at conventions and fairs, including the 1901 Pan American Exposition in Buffalo. In the early 1950s, ownership and control of Welch's transferred to the National Grape Cooperative Association. (Courtesy Sydney S. Baker.)

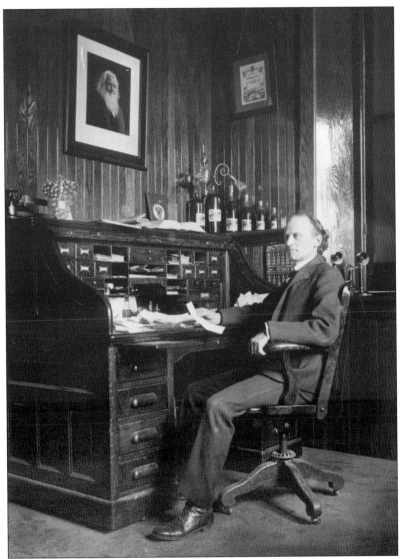

Dr. Charles Edgar Welch (1852–1926) is seated at his rolltop desk beneath a portrait of Thomas B. Welch, his father. The latter, a steward in the Methodist Church, preferred not to serve alcohol for communion services and, thus, made a deliberate effort to find an unfermented substitute. The result of his experimentation was pasteurized grape juice, first made in 1869. Three years later, he abandoned his dentistry practice, as did his son, to operate the business full time. In 1897, influenced by John Heyl Vincent, with whom he had spent a weekend at the Chautauqua Assembly, and impressed by the region's climate and soil, Charles E. Welch decided to relocate his family from Vineland, New Jersey, to Westfield, which thereafter became synonymous with the grape industry. A Chautauqua Institution trustee, six-term mayor of Westfield, and the 1916 nominee for governor of New York on the Prohibition ticket, Dr. Welch was revered as an exemplary community leader and one of Westfield's greatest assets. An interesting sidelight is that even in Dr. Welch's last will and testament, reference is made to the production of "unfermented sacramental wine," which resulted from the family's passion to serve God and to present at communion "the fruit of the vine [not] the cup of the devil's." (Courtesy Patterson Library, Westfield, N.Y.)

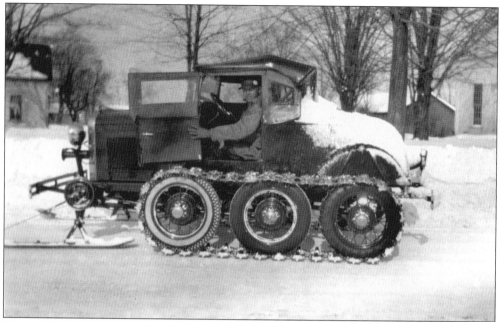

Shown in front of the post office and old church in Dewittville is a snowmobile prototype created by Al Holmes. Holmes, a mail carrier from the early 1930s to 1964, had a 50-mile daily route that was extremely difficult during the winter months. As explained by his wife, former teacher Frances Holmes, he ordered from Minnesota the parts necessary to convert his brand-new 1932 Ford roadster into a suitable cold-weather vehicle. The finished product enabled him to cover his route in a far more expeditious manner. After retiring in 1964, he sold the no-longer needed accessories and the roadster itself. (Courtesy Frances Holmes.)

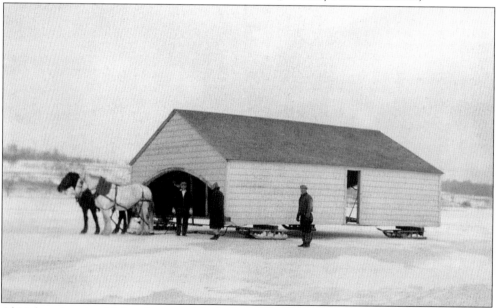

Al Holmes bought this boathouse in Maple Springs in 1936. Another of his creative ideas was to use two horses and rollers to skid the heavy building over the frozen lake to Dewittville, where he used it for a brief period as a mink-raising shelter. (Courtesy Frances Holmes.)

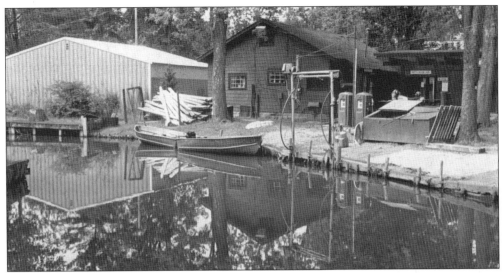

Chautauqua Lake is renowned for its exceptional fishing and has always attracted anglers from miles around. As expected, numerous marinas, launches, and liveries surrounded the lake, and owners catered to fishermen's needs, providing boat rentals, bait, licenses, food, and even campsites. Pictured here is Topsy's Landing, built during the Depression on the Big Inlet near Hartfield Bay. Earl "Topsy" Sparling's modest livery flourished, and his fleet of familiar gray-and-red boats grew to a total of 30 before the family business was sold. Even today, Topsy's Marina remains a fisherman's haven. (Courtesy the *Post-Journal*, Jamestown, N.Y.)

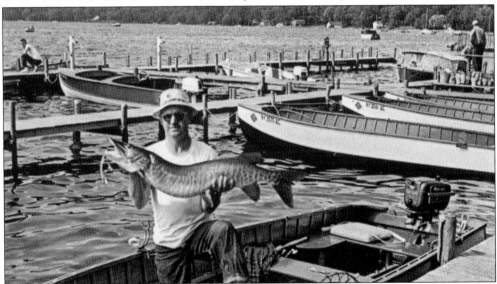

Like Carlson's Livery in Celoron and Kelderhouse's in both Bemus Point and Maple Springs, Norton's Livery, located on Lakeside Drive beside the Hotel Lenhart in Bemus Point, specialized in sales, service, and storage. The business offered vacationers fishing tackle and live bait; rentals of rowboats, canoes, sailing craft, and power boats; gasoline; "tour rides"; and fishing guide services. Norton's cabins were also in demand from late spring to early fall for families and sportsmen who traveled to the Chautauqua Lake region during fishing, boating, and hunting seasons. When vacationers began to own and haul their own boats to the lake, regional liveries suffered a great loss. (Courtesy Kathleen Crocker.)

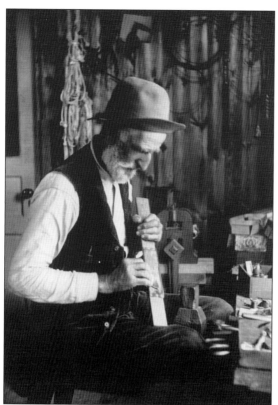

Edward Wilbur Irwin (1844–1932) attended Bryant and Stratton Business College in Buffalo in the 1880s but abandoned a promising career as a certified public accountant to return to his home on Chautauqua Lake near Mayville, now Irwin's Bay. His fishing prowess was unequaled on the upper lake and brought him an income by selling his catches to lakeside hotels. A remarkable hunter and trapper as well, Irwin escorted parties to lodges throughout the United States but faithfully heeded "the call of Chautauqua Lake" each summer. An outstanding carver of both fish and duck decoys, he is seen here with some of his carving implements. His niece recalled that when "Uncle Ed" was nearly blind, he continued to "guide" others to his best fishing spots; his confidence was such that if they were unsuccessful, Irwin would insist that the fault was certainly theirs, not his, because in his mind's eye, they had chosen the wrong spot. (Courtesy Prudence Hiller Putnam.)

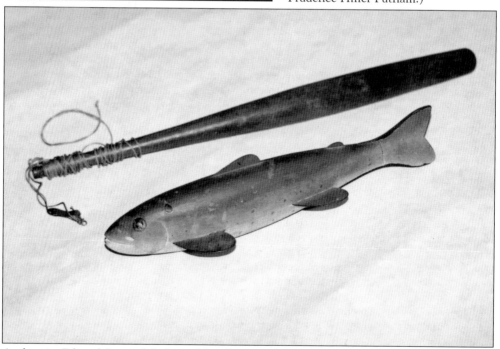

Authentic Edward Irwin fish lures like this one have become priceless collector's items. (Courtesy Jane Currie.)

Seven

FISHING, BOATING, AND OTHER PASTIMES

The Chautauqua Lake region has been a perennial habitat for fish and wildlife. Early reporter Floyd L. Darrow noted that "the woods abounded in game, the lake with muskellunge . . . and the streams with brook trout, shiners and horned dace," providing sustenance to pioneers who were skillful fishermen and hunters and, later, providing recreation for visiting sportsmen.

During the fall and winter months, the region became a hunter's paradise. The once plentiful panther, wolf, wildcat, and otter population dramatically declined or totally disappeared. However, the area is rife with ruffed grouse, wild turkey, ring-necked pheasants, quail, rabbits, squirrels, woodchucks, hedgehogs, muskrats, fox, duck, geese, and the burgeoning deer population.

The lake is a fisherman's paradise as well, with or without ice. A variety of species, including walleyed pike, large- and small-mouth bass, calico bass, white and yellow perch, and black and white crappie, have attracted anglers to the lake's shores and streams. However, the most serious fishermen have willingly traveled long distances to satisfy their addiction for the renowned muskellunge, considered Chautauqua Lake's premier catch.

Most of the muskellunge have been stocked or artificially propagated at lakeside fish hatcheries managed by the state. Back in 1873, Albert Godard took up a collection at a Mayville town meeting to purchase young fish from the Caledonia hatchery. The first hatchery on Chautauqua Lake was established at Greenhurst, near Jamestown, in 1889; there, by the following year, 75,000 muskie had been artificially propagated. Opened in 1903, the fish hatchery at Bemus Point attracted many visitors, who peered into the outdoor troughs and rearing ponds with great curiosity. In 1950, a 70-acre tract was purchased across the lake at Prendergast Point to accommodate a much needed larger facility, which was manned by a small crew, with seasonal employees hired during the netting season.

Both hunting and fishing account for a tremendous number of visitors to the Chautauqua Lake region. According to the State of the Lake Report published in May 2000 by the Chautauqua County Department of Planning and Development, "Chautauqua Lake supports

a sport fishery that ranks fourth in New York State angler use, with an estimated annual expenditure exceeding 11 million dollars."

Through the years, outdoor enthusiasts have experienced vacations in both the summer and winter seasons that combined rest with activity. From organized regattas to solo canoes, boating continues to be a major draw, and every imaginable kind of watercraft is visible at any time on the 17-mile-long lake. Hiking, biking, tennis, golf, and baseball are among the many other pastimes that attract visitors to the area.

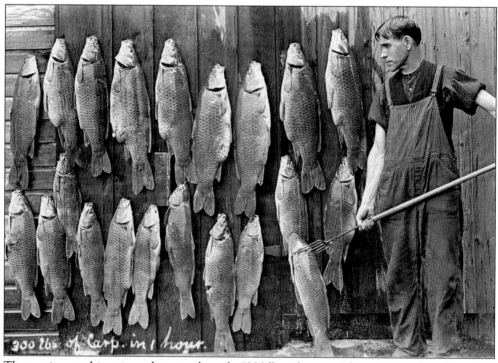

The caption on this unique photograph reads: "300 lbs. of carp in 1 hour." Were they all speared in that time span, or was this another local fish story? (Courtesy Sidney S. Baker.)

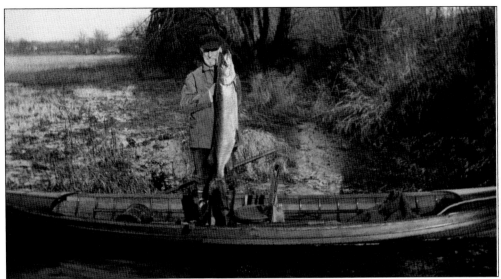

Both photographs on this page feature Edward W. Irwin, famed decoy carver, probably best remembered for his muskellunge fishing prowess in the upper part of Chautauqua Lake. He is standing in his handmade boat, with the Hopson Ice House in the background. This particular photograph once hung in the St. Elmo Hotel, which operated year-round on the grounds of the Chautauqua Institution. Most likely, Irwin, who lived nearby, sold the hotel manager his muskies in the summer and his rabbits in the wintertime. This framed photograph now hangs in the home of a family friend in Vermont. (Courtesy Virginia Hopson.)

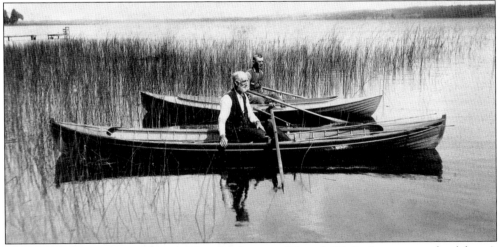

This is another vintage photograph of fisherman Edward W. Irwin out on the lake. A contemporary of Irwin and a "fisherman of considerable repute" in the lower lake was Frank W. Cheney, most likely a friend, since their interests were so similar. According to a newspaper article compiled by Martin Arend and Victor Norton Sr., it was reported on June 29, 1885, that Cheney had caught and brought into Bemus Point 110 fish from Chautauqua Lake in a five-day period. He was once in charge of the fish hatchery and, in 1885, was appointed Chautauqua County's state game and fish protector. Cheney, whose surname is a well-known one around Chautauqua Lake, later served on the Jamestown police force and eventually retired to a lakeside cottage, always remaining near his beloved fishing grounds, as did Edward Irwin. (Courtesy Sydney S. Baker.)

The early pioneers used guns to provide their families with game and waterfowl from the forests and waters of the region. Many young people choose to be hunters today, when hunting is more of a sport than a necessity. Leander Crocker, left, with grandsons Mark, center, and Randy, right, spent time together in training sessions. As in countless families, grandfathers passed on to yet another generation the benefit of their own experiences, attempting to impart the importance of safety, the proper use of shotguns, and a healthy respect for the laws of nature. (Courtesy A. Byron Crocker.)

Because of the abundance of fur-bearing animals in this region, Indians and early settlers used pelts for bartering purposes. Years later, Al Holmes of Point Chautauqua spent much time as a trapper. Before starting out on his daily mail delivery route, he would set his beaver traps, remove his catch, and take it home to skin at the end of his workday. He sold the skins as well as the silver foxes he raised. He is seen in this c. 1951 photograph holding a couple of beavers. Although he gave his wife, Frances Holmes, an exquisite custom-made beaver fur coat, it remains in storage, as she believes it to be "politically incorrect" to wear these days. (Courtesy Frances Holmes.)

Primarily from Bemus Point, members of a local hunting and sportsmen's club proudly pose with their large number of trophies. They are, from left to right, as follows: (kneeling) Bob West, Willie West, Ernie Bohall, Art Carpenter, Jay Bohall, Dick Graham, Chuck Kruse, and Spike Kelderhouse; (standing) Jim West, Jim Gustafson, Hump Bailey, Don Johnson, Fred Gustafson, Louis Farrell, and Bob Shephard. (Courtesy Spike Kelderhouse.)

Donald E. "Spike" Kelderhouse epitomizes the heart and soul of the Chautauqua Lake angler. Since 1939, he has prowled mainly around the upper lake from June to October in search of muskellunge, luring this adversary by trolling with large plugs and spoons. In this photograph taken near his Bemus Point boating business, Kelderhouse proudly displays a 42.5-pound beauty. He attributes his success, first, to an element of luck but, more importantly, to repeatedly returning to his best fishing spots and keeping accurate records for frequent reference. He contends that the lake has remained virtually unchanged throughout his 80 years, and he continues to boast of its beauty during all four seasons. His business has attracted clientele from as far away as Peru, Argentina, Australia, and England, and many of his clients have made return visits to seek his fishing expertise and avail themselves of his charter fishing service. Kelderhouse has attained a reputation as one of Chautauqua Lake's all-time great muskellunge experts and has logged more hours on the lake as a professional than almost anyone else. With a gleam in his eye and a corncob pipe in his mouth, the "Old Salt" admits he has heard and told just about every imaginable fish story and has every intention of hearing and telling many more. (Courtesy Spike Kelderhouse.)

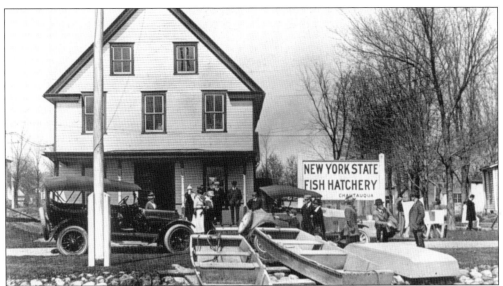

In 1903, rearing ponds were constructed beside this two-story building on South Lakeside Drive in Bemus Point. Visitors and residents remember walking beside the propagation ponds and troughs, fascinated by their contents. The first artificial propagation of muskellunge began in the late 1880s, when experiments evidenced the practicality of artificial spawning to accommodate the increasing number of fishermen to Chautauqua Lake. In 1950, fingerling muskies began to be reproduced with greater scientific study and under more sophisticated conditions at the enlarged facility at Prendergast Point near the Chautauqua Institution. (Courtesy Kathleen Crocker.)

In the 1950s and 1960s, there was an overabundance of calico bass, or crappies, in Chautauqua Lake. They would be caught by the thousands along with muskellunge in the fish hatcheries' pound nets. Hatchery worker Mark Bue is intently separating them out before returning them back into the lake. Occasionally, a surplus of crappies would be transferred to Delaware Park in Buffalo and to Hyde Park in Niagara Falls to provide urban fishing opportunities. (Courtesy Clarice Gates.)

Raymond Norton, a native of Randolph in Chautauqua County, was superintendent of the New York State Fish Hatcheries at Bemus Point and then Prendergast Point for more than 40 years. During his lengthy tenure, huge progress was made in the restocking program of quality Chautauqua Lake muskellunge. Because of Norton's personal concern and dedication, several million muskellunge eggs were hatched yearly, ensuring their continuance for thousands of anglers who visited the region to test their patience and skills in catching muskies, the greatest of freshwater game fish. According to an August 1953 *Sports Illustrated* article, which featured this photograph, Norton "literally sleeps beside his brood to be sure the muskies do not lack water and to keep them from being molested too much by visiting tourists, raccoons, kingfishers, and grackles." (Courtesy Clarice Gates.)

After netting the muskies, the stripping, or milking, part of the propagation process was a complicated task, lovingly performed by fish hatchery employees, as seen here. Deft hands and teamwork were needed to stroke the muskie's stomach and remove the spawn while a partner clamped his hands firmly over the sharp-toothed jaws of each fish. Following fertilization of the quarts of female eggs, the milk was then stored in jars for about three weeks until the eggs hatched into fingerlings. (Courtesy the *Post-Journal*, Jamestown, N.Y.)

Pleasure boating on Chautauqua Lake has changed considerably through the years. The elegance of the Victorian era is evident in the apparel of these boaters. Despite the occasion, on water or land, ladies generally donned hats or bonnets and long skirts and dresses, while gentlemen were decked out in suits, vests, hats, and, occasionally, blazers for informal day wear. The above party seems to be going nowhere fast while the steamer passes by. (Courtesy Patterson Library, Westfield, N.Y.)

On the other hand, this foursome appears eagerly bound for a particular destination. These classic Chris-Craft cruisers provided fast transportation from one dock to another and for hotel hopping, which was once in vogue. (Courtesy Mary Jane Stahley.)

Because the Greenhurst Hotel served as its social center, the Chadakoin Crew Club relocated when the hotel closed. It moved to the Lakewood Country Club boathouse on the opposite shore and changed its name to the Chautauqua Lake Yacht Club, which remains active today. Not only did the club compete with the Chautauqua Crew Club, but it also hosted crews from Spain, Portugal, Brazil, and Newfoundland during the world-class International Snipe Championships in 1946. (Courtesy Mary Jane Stahley.)

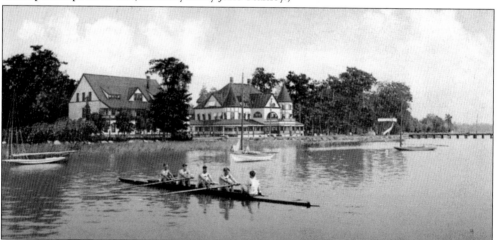

Founded in 1894, the Chadakoin Rowing Club was located adjacent to the Greenhurst Hotel, at the lower end of the lake. Attracting enthusiastic college athletes during their summer vacation, the club sponsored frequent sailing and speedboat races over its triangular course. Colorful annual regattas delighted spectators, who lined the shore in boats or on watched from passing steamers. The fleet also consisted of catboats, canoes, and a variety of motor launches—a craft for everyone's pleasure. (Courtesy Sydney S. Baker.)

From 1895 to 1917, rowing took preference over sailing as a popular sport at colleges and universities. Like Jamestown's William Broadhead, who was a member of the Yale University crew, athletes chose to practice during the summer months as well. To maintain their strength, endurance, and stamina, they formed the nucleus of the membership of local crews. Competitive annual rowing races over the home course of the prior winner were held between the Chadakoin and Chautauqua Crew Clubs and were usually followed by trophy presentations and social activities for members and their guests. Although most formal crew racing ended before World War II, both clubs continued to promote yacht racing and aquatic sports for amateur sailors. (Courtesy the *Post-Journal*, Jamestown, N.Y.)

Chautauqua Lake is truly a vacationer's paradise. Jim Wallace, on this old rainbow sailboat, appears to indulge himself on this occasion as he enjoys the lake's solitude. This would have been an ideal advertisement for the Chautauqua County Visitors' Guide. (Courtesy Sherry Johnson.)

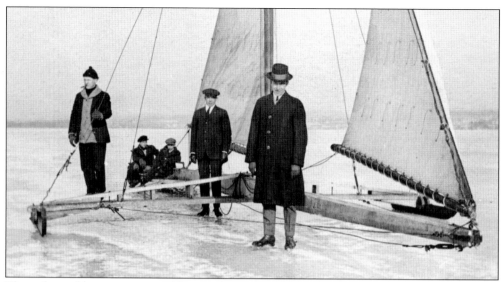

Throughout the years, western New York snowfalls have impacted tourism. Bertrand Taylor captured these dapper ice sailors out on the lake near Mayville. Attired in topcoats, hats, suits, and gloves, they appeared to be undaunted by the frigid temperature, as they used ropes and cables to maneuver their vessel on the frozen lake. Hardy outdoor enthusiasts also spent winter weekends ice-boating, skating, skiing, sledding, tobogganing, and coasting around the area. There are currently over 400 registered snowmobiles in the county; many operators arrive from Ohio and Pennsylvania to bask in Chautauqua's winter wonderland. (Courtesy Devon Taylor.)

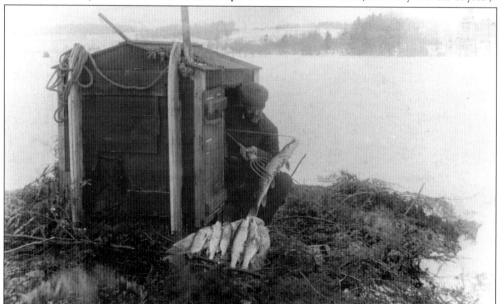

Spearing muskellunge through the frozen lake was especially commonplace in the 1880s, although the practice continues today with legal regulations. Wintertime diehards set up a protective shelter, or house, over a hole in the ice through which they peered down, inserting carved wooden minnows, like those made by Edward Irwin, to attract the muskies. Extreme patience continues to be a prerequisite for this sport, which enabled anglers to fish year-round on Chautauqua Lake. (Courtesy Mary Jane Stahley.)

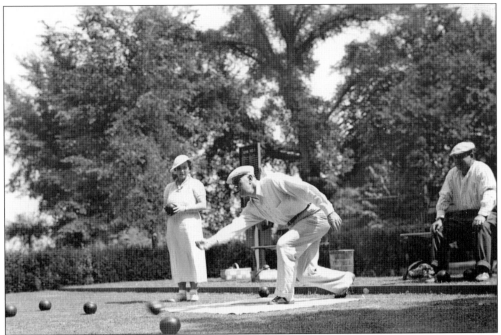

The Victorian era has been called one of "carriages, lawn croquet, and lemonade." The Chautauqua Institution carried on this tradition in grand style, and its court was considered among the finest anywhere. Roque, a form of croquet, was played on several courts in the ravine near the Girls' Club. Today, lawn bowling and shuffleboard are popular pastimes near the waterfront Sports Club, along with boating, bathing, bicycling, tennis, and golf. (Courtesy the Chautauqua Institution Archives.)

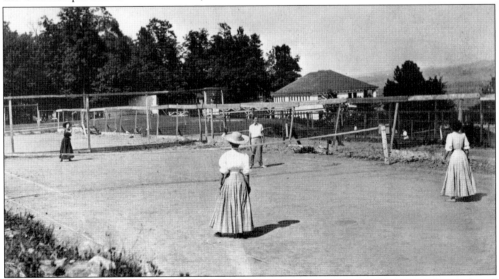

On a visit to England in 1878, John Heyl Vincent discovered the game of tennis and introduced it at Chautauqua. He had one of the first tennis courts in the United States built between his own cottage and the Chautauqua Arcade, near the lakefront. Tennis, of course, was a popular offering at hotels and parks all around the lake, although the attire might not have always been so formal as that seen above. (Courtesy the Chautauqua Institution Archives.)

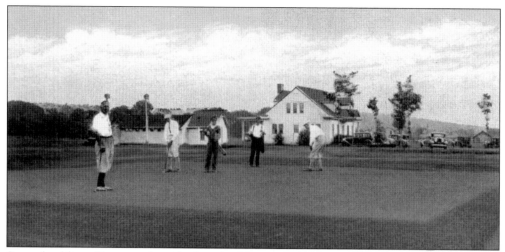

Several public golf courses flourished in the Chautauqua Lake region, many of which provided not only quality greens and fairways but also spectacular views. The scenic, well-manicured nine-holes at Point Chautauqua paralleled the highway, ending down by the lakeshore, with a hardy climb or funicular ride back up to the clubhouse. The plain, white wooden Bemus Point clubhouse in the background of this photograph appears unchanged today, although the course opened in 1920 and has had continuous fair-weather use every since. Premier golfers such as Byron Nelson and Sam Snead, however, opted to play the 18-hole course, designed by Donald J. Ross of Pinehurst, North Carolina, which opened in 1924 across the road from the Chautauqua Institution. Golf remains an integral part of the Chautauqua experience even today. (Courtesy Mary Jane Stahley.)

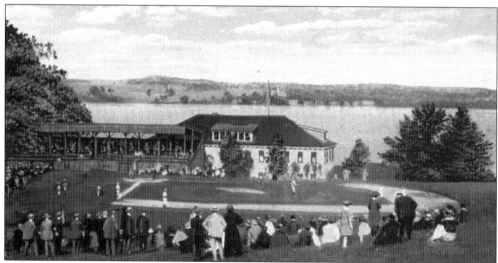

As early as 1900, baseball was a popular spectator and participant sport in the Chautauqua Lake region. In the 1880s, Alonzo Stagg, an instructor in the physical culture program, attracted crowds to the Chautauqua Institution. Later, Al Sharpe's presence was a similar magnet. The latter, for whom the athletic field was named in 1965, became both a football coach and athletic director at Yale University. Organizations, as well as individuals, loved the sport; a 1920 article in the "Chautauqua News" section of the Jamestown newspaper reported on a game played between members of the Boys' Club and those of the symphony orchestra. Baseball mania had arrived. (Courtesy Kathleen Crocker.)

Art Metal Construction Company

STEEL OFFICE FURNITURE
BRONZE & STEEL INTERIOR EQUIPMENT

ADDRESS THE COMPANY

ATTENTION T. G. Carlson

EXECUTIVE OFFICES & FACTORIES

JAMESTOWN, NEW YORK

June 23, 1925.

Manager Chautauqua Base Ball Team,
Chautauqua,
New York.

ALL AGREEMENTS SUBJECT TO DELAYS BEYOND OUR CONTROL. PRICES AND TERMS FOR IMMEDIATE ACCEPTANCE SUBJECT TO CHANGE WITHOUT NOTICE.

Dear Sir:

It has been the custom for the past five or six
years at the annual Art Metal Picnic that the
Chautauqua Base Ball Team and the one represent-
ing our plant to meet for a royal battle on the
picnic grounds at Midway Park.

We do not wish to make this year an exception
and believe that the teams we have organized to
represent the Art Metal are perfectly able to
give you a real tussle for the honors.

The date set for our picnic is July 18th, and
though we have read nothing in the local papers
relative to the Chautauqua Team being organized
we believe that you will, without a doubt, have
a representative team on the field by the day
set for our picnic.

Kindly phone or wire immediately at our expense
so that we may know what the outlook will be for
a game as proposed. It is necessary that we
hear from you at once so that we can arrange
for the printing of our programs without delay.

Yours very truly,

ART METAL CONSTRUCTION COMPANY

TGC*AS

Manager Base Ball.

WORLD'S LARGEST MAKERS OF STEEL OFFICE FURNITURE

The Chautauqua Institution baseball team competed against various local teams not only at Chautauqua but also in Jamestown and at Midway Park. In addition to the organized Grape Belt League and Chautauqua Baseball Association, individual companies such as Art Metal Construction chose to "battle royal" with players from the Chautauqua baseball team, as revealed in this invitation. (Courtesy the Chautauqua Institution Archives.)

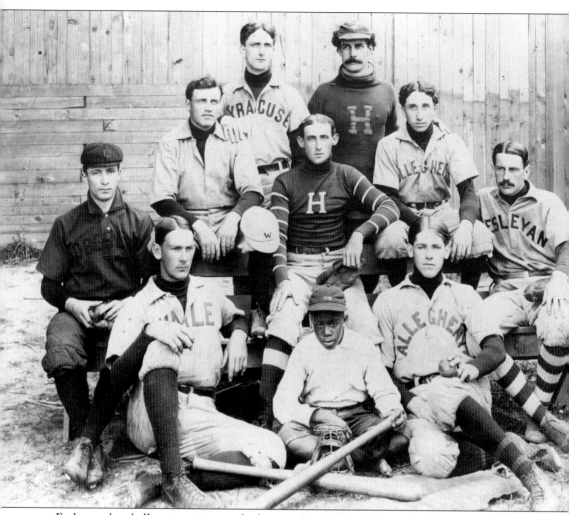

Early area baseball competitions took place on the athletic fields at the Chautauqua Institution and at Celoron Park. Outstanding athletes from various colleges, including Syracuse University and Allegheny College in nearby Meadville, Pennsylvania, were represented on Chautauqua's physical education baseball team. For just a few cents, fans could board the Jamestown Street Railway and transfer to Celoron Park to spend quality grandstand time. They could watch amateur and semiprofessional teams from Buffalo, Lockport, and Syracuse, and Pennsylvania teams from Bradford, Warren, and Oil City. These games were a prelude to Jamestown's affiliation with the major league farm club system, which began in the 1940s. (Courtesy the Chautauqua Institution Archives.)

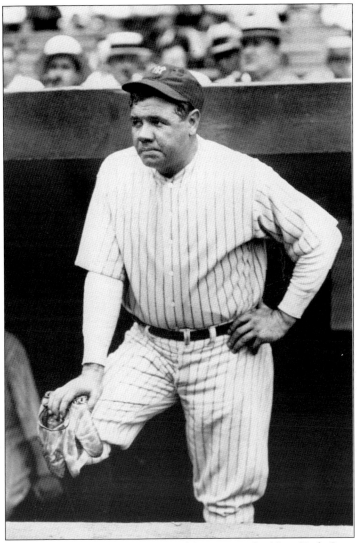

After the New York Yankees lost the 1921 World Series to the New York Giants, Babe Ruth and several other all-star players barnstormed through Buffalo, Elmira, Jamestown, and other New York State communities. They made their historic appearance at Celoron Park, the original home of professional baseball in Jamestown. Despite the downpour, Ruth hit a ball 500 feet over the trees and out into Chautauqua Lake during a long-distance hitting exhibition prior to the actual game. After the game against semiprofessionals from the Jamestown area, the youngsters' idol reportedly spoke to an audience of boys at the Winter Garden Theater, addressing the issue of cigarette and tobacco usage. After the completion of the 4,200-seat Municipal Stadium in 1941, Jamestown became affiliated with a string of parent clubs, including the Detroit Tigers, the Los Angeles Dodgers, the Atlanta Braves, the Boston Red Sox, the Montreal Expos, and the Pittsburgh Pirates. Before the stadium was renamed College Stadium in the 1960s, under the ownership of Jamestown Community College, many minor league players from Pennsylvania, Ontario, and New York (the P.O.N.Y. League) advanced from their home field to major league careers. In 1994, the city proudly celebrated its 50th year of professional baseball, thereby providing Jamestown citizens wholesome family entertainment at its best. (Courtesy Russell E. Diethrick Jr.)

BIBLIOGRAPHY

Anderson, Arthur Wellington. *The Conquest of Chautauqua: Jamestown and Vicinity in the Pioneer and Later Periods As Told by Pioneer Newspapers and Persons*, Vol. I. Jamestown, New York: Journal Press Inc., 1932.

Baldwin, Neil. *Inventing the Century*. New York: Hyperion, 1995.

Chautauqua Lake Steamboats. Jamestown, New York: the Fenton Historical Society, 1971.

Conkling, Edgar C. *Frederick Law Olmsted's Point Chautauqua: The Story of an Historic Lakeside Community*. Buffalo, New York: Canisius College Press, 2001.

Curtis, Dorothy Hopkins. *A History of Westfield, Part I, 1802–1952*. Westfield, N. Y., 1955.

Doty, William J. (ed.). *The Historic Annals of Southwestern New York*, Vol. I. New York: Lewis Historical Publishing Company, 1940.

Ebersole, Helen G. *Chautauqua Lake Hotels*. Jamestown, New York: the Fenton Historical Society, 1992.

Edson, Hon. Obed (historian). *History of Chautauqua County, New York* (illustrated). Boston: W. A. Ferguson and Company, 1894.

Gustafson, Ron. *Midway Park "A Century of Fun," 1898–1998*. Nashua, New Hampshire: Midway Museum Publications, 1996.

Hazeltine, Gilbert W., M.D. *The Early History of the Town of Ellicott, Chautauqua County, N.Y. compiled largely from the Personal Recollections of the Author*. Jamestown, New York: Jamestown Printing Company, 1887.

Irwin, Alfreda L. *Three Taps of the Gavel: Pledge to the Future: the Chautauqua Story*. Westfield, New York: Westfield Republican, 1987.

Jamestown and Chautauqua Lake Trolleys. Jamestown, New York: the Fenton Historical Society, 1974.

Leet, Ernest D. (ed.). *History of Chautauqua County, 1938–1978*. Westfield, New York: Chautauqua County Historical Society, 1980.

McMahon, Helen C. *Chautauqua County: A History*. Buffalo, New York: Henry Stewart, 1958.

Moe, M. Lorimore. *Saga From the Hills: A History of the Swedes of Jamestown*. Jamestown, New York: Fenton Historical Society, 1983.

Morrison, Wayne E. *Morrison's Annals of Western New York: A Comprehensive History Embracing Every County, City, Town, Village and Locality*. Ovid, New York: Morrison and Company, 1975.

Mulé, Dave. *Across the Seams: Professional Baseball in Jamestown, N. Y.* Mattituck, New York: American House, 1998.

Rothra, Willis H. *Two in a Bucket: A Personal Account of Ice Harvesting*. Stow, New York: Overlake Enterprises, 1984.

Stahley, Mary Jane (compiler). *History of the Village of Bemus Point*, 2001.

Taylor, Devon A. *Mayville: A View Through Time*. Jamestown, New York: Jamestown Advertising and Printing Company, 1993.

Thompson, B. Dolores. *Jamestown and Chautauqua County: An Illustrated History*. Woodland Hills, California: Windsor Publications, 1984.

Vincent, John Heyl. *The Chautauqua Movement*. Boston: the Chautauqua Press, 1886.